OIL PAINTING MATERIALS
And Their Uses

By William F. Powell

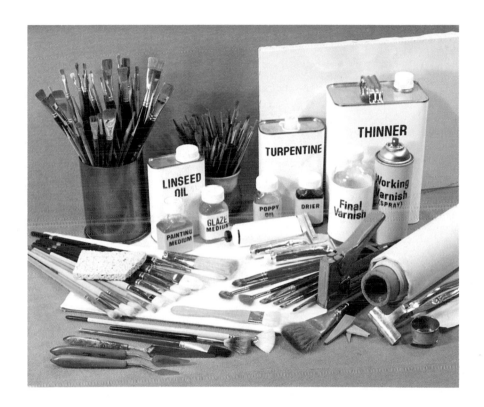

Walter Foster Publishing, Inc.
23062 La Cadena Drive, Laguna Hills, CA 92653

CONTENTS

INTRODUCTION

The subject of oil painting materials is a broad one. Not only does it include physical tools like brushes, canvases and knives, but also the various oils, mediums, thinners, and the slight differences in the performances of each. Sometimes one oil can substitute for another for a particular task, and sometimes there is no substitute.

Throughout the history of oil painting, artists have experimented, tested, noted results, and cast aside the ingredients or items that proved to be either nonpermanent or that would undermine the work, resulting in the rapid deterioration of the painting. Only proven ingredients are used in the manufacture of oil paints, and, because the best, purest ingredients are costly, the paints are expensive. It is best to buy the highest quality paint one can afford. This helps insure that the painting we have worked on so hard and long will not disassemble itself on someone's wall as time goes by.

In today's modern, "hurry-up" world, a common attitude is that an oil painting must be accomplished in one sitting, using only wet-in-wet techniques. And, along with this hurry-up feeling, the artist may attempt to cut corners or use materials that are more in the "gimmick" line (in reality, there are many techniques which require the painting to dry between sittings so the paint can be manipulated on the surface for the desired effects). But remember, it is always best to use the proven materials!

In this book, only the proven, tried, and tested materials will be discussed. Over the years I have tested and experimented with many formulas. At one time my wife and I owned a house with a flat, Spanish-style roof. The roof was my testing ground for many mediums, varnishes, etc. Some items actually survived three years of exposure to the hot California summer sun and the winter rains. After becoming acquainted with the materials in this book (which covers all of the usual ones needed by an oil painter), try some experiments of your own — they can be very interesting!

Oil painting brushes are probably the most misunderstood tool of all. For this reason, we will begin with them. There are so many types of hair and bristles available that a beginner can become confused as to which brushes to buy and which brush to use for what purpose.

Although there are many types of brushes available, it is not necessary to purchase them all in the beginning. A few simple brushes are all that is needed. After we become acquainted with each one, we might decide to add to our supply. Many professionals work with a simple selection of their favorite brush types even though they might have nearly a hundred. At the end of the brush section (page 29) there is a list of brushes that will make a good starter set.

I truly hope that this book will accomplish the following:

- Introduce and acquaint the reader with the different tools and materials used in the art of oil painting.

- Explain how these tools are used through simple but thorough explanations, diagrams and sketches, photo illustrations, and sometimes combinations of all.

- Act as a materials reference book for the student, hobbyist or professional.

- Answer the many questions that arise during the course of the first steps of using a new tool.

- Correct misunderstandings of any tool or material and their intended function in oil painting.

- Dispel any misinformation regarding the use of materials and chemicals not refined for the art of oil painting.

OIL PAINTING BRUSHES

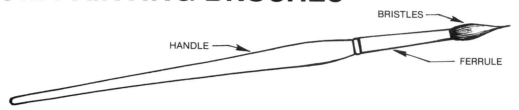

All brushes are made up of three parts: the handle, the ferrule, and the bristles. There are many styles and qualities of oil painting brushes. They vary not only in shape and size, but, most importantly, in the material used to make each brush. Each style of brush is designed to perform particular tasks depending on the material used for the bristles, the cut, length and taper of those bristles, the depth of insertion into the ferrule, and the shape of the handle. Watercolor brushes are made with short handles, and most oil painting brushes of sable and other natural hair have long, slim handles. Bristle brushes usually have long and heavier-styled handles, depending upon the width of each brush.

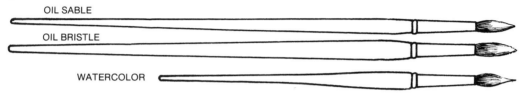

Brushes also vary greatly in price. This, again, depends on the type of bristle or hair and the craftsmanship used in producing the brush. The finest brushes from the top manufacturers are handmade and far from cheap. The finest hair and bristles are selected for their lasting quality and toughness, and mostly for their flexibility and memory for springing back, and the proper thickness, point and taper of each hair in relationship to all other hairs used in the same brush.

All the bristles and hair used in fine brushes are hand-combed and set so that each one will achieve that uniform length, quality, strength and thickness. These are then placed into the ferrule by hand, glued, crimped, and individually inspected before being released to the consumer.

There are also a number of good oil painting brushes available that are not as expensive as the very finest. In most instances they will perform just as well while we are learning. It is a waste of an expensive sable hair brush to use it to scrub in an experimental project onto raw rough canvas. Tough, inexpensive bristles will work just as well.

The following information regarding the different brushes and their uses is presented in two sections: natural hair brushes and synthetic hair brushes. Standard inch measurements will be used to describe the brushes since brush makers do not adhere to a standard width for the same size number. For example, a #20 sable-style brush can vary as much as one-half inch in width from maker to maker.

Natural Hair Brushes

The type of hair or bristle and the depth and attitude that it is set into the ferrule have a great effect on the performance of the brush. Usually, the deeper the hair is set into the ferrule, the more memory and resiliency the brush has.

There are basically two types of natural hair used: one is soft hair, the other is stiffer and is referred to as "bristle." There is a wide range of quality and sources for both types. The ideal hair and bristle must meet certain specifications.

The natural end of the hair or bristle is set so as to form the tip of the flat or filbert-style brush and the point of the round one. These ends are never cut in the finest brushes, but they are cut in some of the inexpensive ones in order to achieve an evenness at the end of the brush. It is most desirable to paint with the natural end of the hair or bristle. This allows us to obtain a chisel tip or pinpoint at the end of the brush for fine work. The cut brushes cannot achieve a fine edge or point.

There are names for all styles of brushes. We will study these as we go from brush to brush. As an introduction, notice the different shapes of the basic set of brushes shown below.

Now that we have studied some of the general methods and materials that go into brush making, let's look at each brush and how they are used in oil painting. To do this, we will begin with the brushes that are made with bristle.

BRUSH CONSTRUCTION

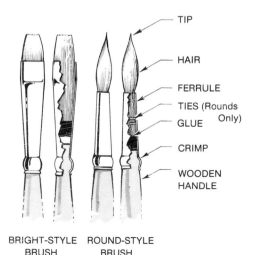

- TIP
- HAIR
- FERRULE
- TIES (Rounds Only)
- GLUE
- CRIMP
- WOODEN HANDLE

BRIGHT-STYLE BRUSH ROUND-STYLE BRUSH

BRUSH STYLES

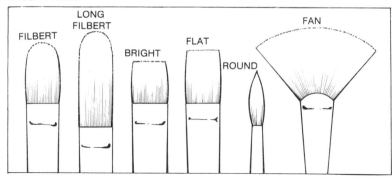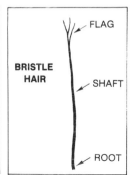

Bristle Hair Brushes

Bristle brushes are considered the workhorses of the oil painter. These brushes are produced using white and black bristles. The finest bristle brushes made for artists' oil painting are constructed of white bristles which are taken from hogs and boars of the Far East and bleached to a uniform whiteness. Good bristle has natural, multiple tips known as "flags." These flagged ends interlock to help move thick paint. The width of the bristle gradually increases to the base of the hair. The corners of the bristle brush cannot be made quite as clean and sharp as a soft hair brush because of the flag tip.

A fine bristle brush requires as much craftsmanship in making as other brushes do. Some hog bristles curve naturally, and a skilled brush maker will set these bristles so as to curve into the brush. This stops the tendency to spread outward and lose the shape of the brush. The filbert is a good example of this type of bristle setting.

Bristles are used in a number of oil painting brush styles.

Filberts

Filberts are probably the most versatile of the flat-style bristle brushes, allowing more variety of manipulation and stroke because of their particular shape. A very fine filbert will curve inward from side to side and also slightly from the flat of the brush. The rounded shape of the filbert allows this brush to be used not only for applying smooth paint, but also for certain textural effects no other brush will create. The filbert will not plow or dig into a wet underbase as harshly as a flat style. This is very desirable when covering an area with several values of paint for an atmospheric effect.

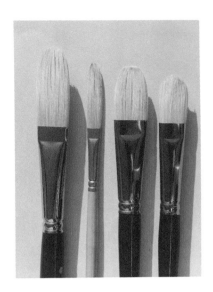

Filberts are available with long, extra long, and short bristles, and in a range of widths, from about 1/4" to 2" by some manufacturers. A versatile size is either a #8 (about 1/2"), a #10 (about 3/4"), or a #12 (about 1"). These brushes are not used for obtaining the detail a soft sable will give; they are used more aggressively.

Following are some examples of the versatility of the filbert brush in use:

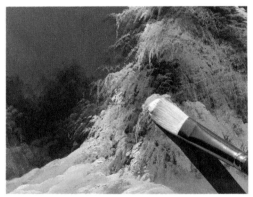

By using the rounded tip of the filbert and lightly applying the paint, the effect of pine branches and snow-laden boughs can be accomplished.

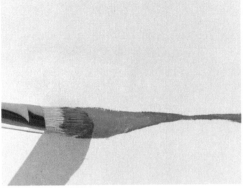

When well-loaded, the filbert can create a thin line and then a very thick line by turning the brush as the line is drawn. It is very controllable.

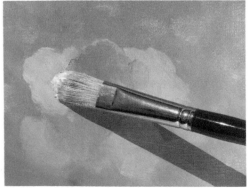

Because of its rounded shape, the filbert is capable of applying large amounts of wet paint onto a layer of wet without plowing deeply into the underpaint.

With a limited load of paint, the rounded tip can be used to create the edges of cloud forms. Press lightly for delicate forms and blends.

By pushing and twisting the brush at the same time, the paint is stamped onto the canvas in the form of bushes, as shown above. Stamp the paint on and pull the brush away. Do not drag the brush or grass-type strokes will result. Paint the dark forms first, then using the same technique, paint the lighter colors to form the bushes. In the example below, the basic forms are stamped in with the pushing-twisting method and then the lighter reds, oranges and greens are painted onto them. After the basic bushes are established, the final highlights and twigs are painted in with a small brush.

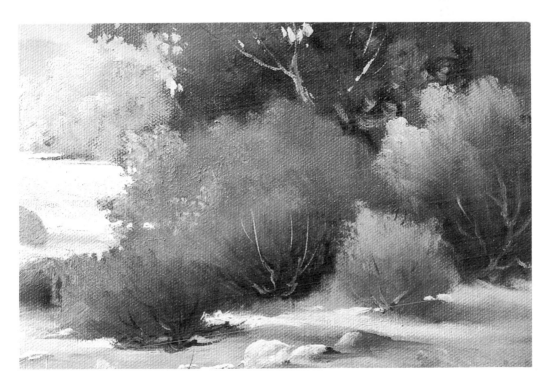

Brights

The bristles in a bright are shorter than those in other styles. They are the same as, or just a bit longer than the width of the ferrule. They are thinner than the filbert and the flat. The short bristle allows for more firmness, yet still has some flexibility and spring. The bright is used where thick amounts of paint and texture are desired, and for rough and vigorous applications of paint. Brights will leave brush marks in the surface more readily than other styles. They have a good square corner.

Brights are available in a wide range of sizes, from approximately 1/4" to 2-1/4" wide. Some manufacturers make special sizes which are even wider.

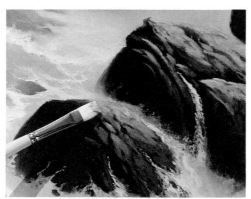

Here the bristle bright is used to apply Yellow Ochre highlights to rocks to obtain the effect of texture and form. A lot of paint is applied very boldly and thickly.

Using the corner of the bright, the paint is tapped on in patterns that appear to be various types of flowers and leaf forms. Change angles often.

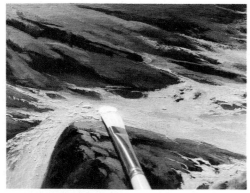

Notice the texture obtained with the heavy load of paint and the method of application with the bright. This adds to the overall texture in the painting.

A well-cared-for bright will draw a fairly fine line when light pressure is applied and the paint is thinned slightly. Shape the point like a chisel.

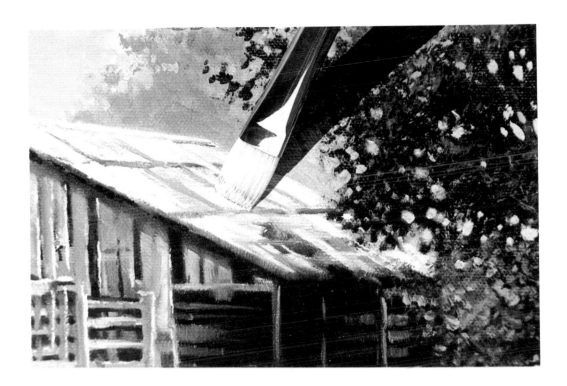

A large brush can be used in a very small area if loaded correctly for the job. Here, a bristle bright is used to apply shingles on a barn roof. By drawing the brush at the proper angle of perspective of the roof angle, a simple, single stroke is all that is needed. For this job, a light paint load is used. A larger load is used below on the wave and a sideways stroke is needed to maintain the perspective of form for this application. Always think of this technique as drawing with your brush. Allow the stroke to follow the shape of the object being painted for good perspective depth.

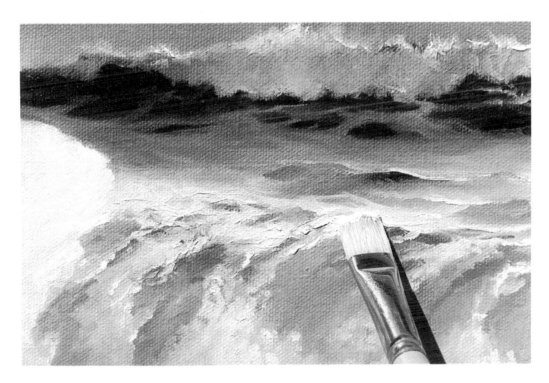

Flats

Flats have a longer body of bristles than brights which gives them more elasticity. These longer bristles are good for the final strokes of a painting where less texture is desired and for blending the wet paint. The longer bristles are usually one and one-half times longer than the width of the ferrule. Flat-styled brushes are much more versatile than round ones and can create a greater variety of strokes and final surfaces on the painting. The flattened ferrule and the length of the bristles make the flat a very important tool when using softer or more buttery paint. They are capable of very soft blends, and the strokes can be applied freely and still remain delicate in touch.

Flats are available in a range of sizes, from 1/4" to 2-1/4" wide. Some manufacturers make special sizes that are even wider.

The flex of the flat allows us to apply a color over a very wet underpaint without plowing and digging. Soft-color blends are possible with this brush.

Applying the highlight whites onto a dry wave is easy with this flat style. The highlight will appear to be blended by softening with a dry brush.

When using the flat bristle in a dry state, delicate blends can be achieved. Softly blend by changing directions of the stroke to avoid monotony.

A flat is capable of painting thin lines, but is slightly more difficult to control than the bright because of its flexibility.

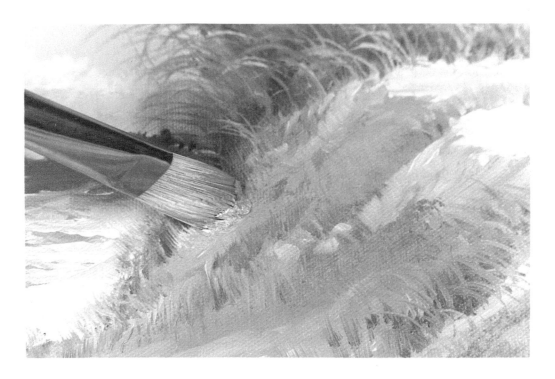

A large flat can be used in small areas to deliver good amounts of paint for impact of texture and color, as shown above. The grey in the sand dunes will give physical texture to the painting as well as color when applied in this manner. Because the brush is so flexible, this can be accomplished right over wet paint. The same idea of overpainting is shown below as the blue shadow snow color is brushed onto the mountain. Again, make the angle of the brush and stroke follow the perspective of the form being painted. Angles and planes are discussed in my Artist's Library book, *Perspective*.

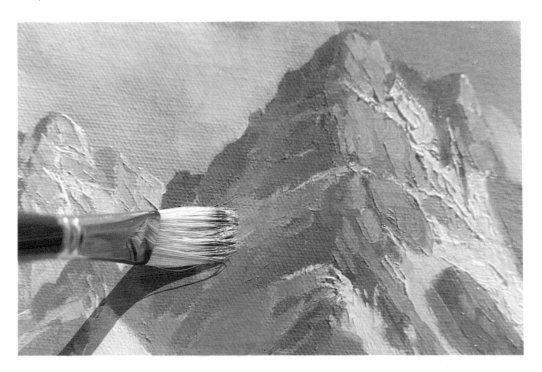

Rounds

There are several styles of round brushes. Some are very pointed, some are less pointed or more blunt, and some are made with a flat end for stenciling and stippling. Bristle brushes that are shaped with a point will never be as pinpoint sharp as brushes made from pure red sable hair. There are, however, some bristle rounds that have a very nice graduated point at the tip. A round bristle brush tapers gently from the ferrule to the point style the manufacturer desired. Rounds are excellent brushes for drawing. The bristles begin uniformly at the ferrule, and a variety of widths of stroke can be obtained by changing the angle and pressure on the brush. The tips of the blunt-end rounds are very good for small blends. All rounds can be used for general painting.

Rounds are available in sizes from 1/8" to 3/4" ferrule width for general painting. Some larger specialty brushes are available from various manufacturers.

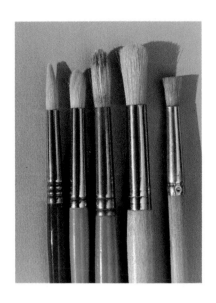

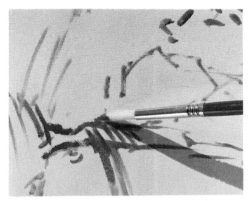

The round bristle brush is a valuable tool for sketching the subject onto the painting surface. By varying the pressure, the line thickness changes.

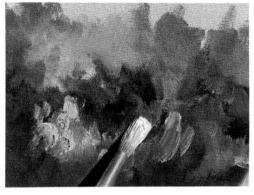

Here, a more blunt-end round is used to paint broad textured blends. Wet-in-wet as well as wet-on-dry techniques are possible with this versatile brush.

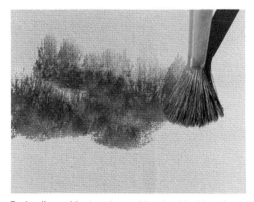

By loading a blunt-end round brush with thinned, very wet paint, and applying quite a bit of pressure, grass, weed, and rough textures can be obtained.

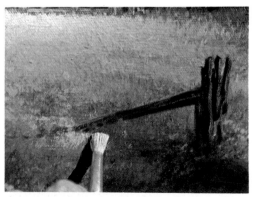

The flat end stippling brush can also be used for painting textures like grasses. By tapping the paint onto a dried surface, we can control accents.

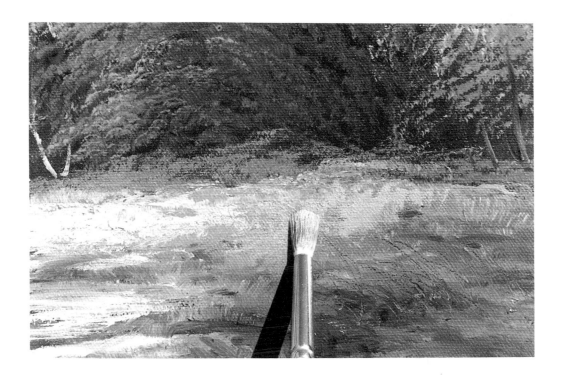

A blunt-end round is used to create the effect of lighter clumps of grass by rolling it across an area that has been underpainted. This rolling technique is valuable for many other textures as well. By laying the brush on its side while rolling it, we benefit from the coarseness of the bristles themselves. Below, the same brush is being used to paint puffs on the falling foam. Short strokes that are quickly pulled off the surface give the illusion of blends. The coarseness of the bristles helps prevent over-blending. When used with care, however, good detail is possible.

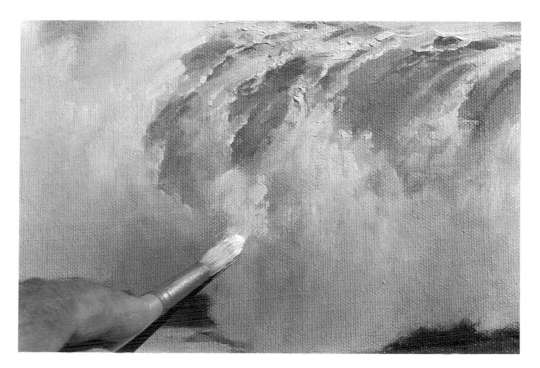

Fitch

The word "fitch" in the brush world has two definitions: one refers to an inexpensive variety of sable-type hair, the other to a specific design and trim of a brush. This design results in a stiff, but flexible brush that is thicker and more oval than most of the other flat styles. The bristles also taper to a chisel-shaped end. A fitch is a good brush for lettering and excellent for general painting as it will hold a good load of paint and the chisel tip allows for smooth spread and control. They are made with both square and angled tips, in bristle and soft hair. They are available in a variety of sizes, from 1/4" to 2" wide and up.

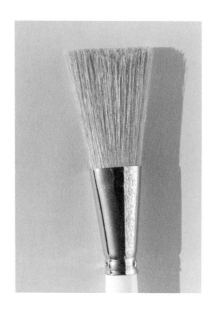

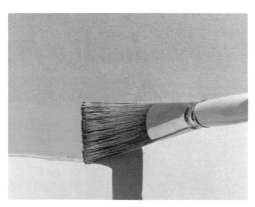

The fitch brush holds a good load of paint and, because of this, is known for the smooth, even-coating it can produce. It also has good flow control.

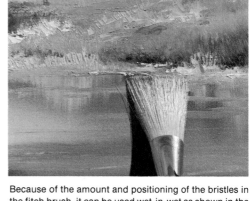

Because of the amount and positioning of the bristles in the fitch brush, it can be used wet-in-wet as shown in the strokes above.

The softness of touch of a dry fitch allows for delicate blends of several colors without losing the colors. The stroke is light and whisping.

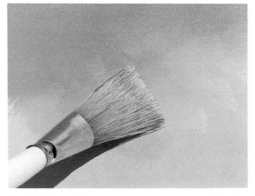

The fitch is great for applying several colors and blending as we go because of the touch of the brush. Notice how flexible the bristles are.

Large Sizes

There are larger sizes of bristle brushes available with different handle styles than the usual oil painting brush. These larger brushes are used not only as paint-spreading tools, but also as texturing tools. For example, a large brush can be used to give the impression of a broad-leaf tree when the tip is loaded with buttery paint and stamped onto the canvas in a particular design. Whether or not these types of brushes are used depends on how much drawing and detail one wishes to invest in the painting. These brushes are available in art supply stores and commercial paint stores. The quality varies in these just as in the oil painting brushes discussed previously. These brushes are available from various manufacturers in a range of sizes, from 1″ to 8″ wide (at one time there was even one 12″ wide).

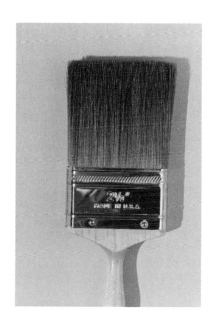

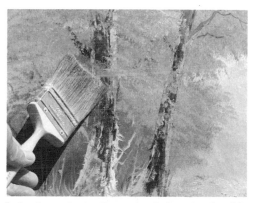

By loading and using the corner of a large brush, a fair impression of leaves and foliage can be stamped onto the canvas. An illusion of detail results.

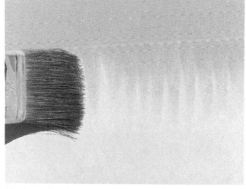

Moving a brush up and down while pulling it creates a sawtooth effect. This is then blended by whisping the brush across the sawtooth. A great effect!

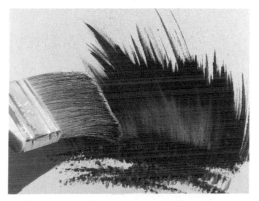

By dragging the brush up and off the surface, an underpainting is achieved that can be used for overpainting grass, fur, hair, etc.

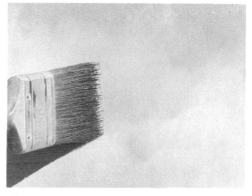

When applied lightly, a large brush can make very soft blends over wide areas. Wipe the brush often in order to keep the colors clean.

Soft Hair Brushes

The bristle brush is generally used for paint application and is considered the standard brush for the oil painter. The softer haired brushes are used for more detail and delicate wet-on-wet manipulations.

These soft hair brushes are made of hair from a variety of animals. They range from pure red sable to ox, badger, skunk, fitch, squirrel, horse — even to monkey hair. A camel-hair brush is made from various animal hair, but not from the camel. It is often a blend of several types; squirrel hair is the most common. The better brushes are made with hair that has proven to be the best for the purpose by years of application and lasting quality of hair. The tips of the soft hair sable brushes, unlike the flagged tips of the bristles, taper down to a very sharp point. The body of the hair shaft bulges around the middle. This is referred to as the "belly." The hair then tapers down to a more slender width at the root end.

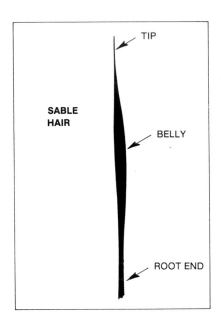

The root end is set into the ferrule. Generally, the more length of hair that is set into the ferrule, the more spring the brush has. Some brushes are set with the belly of the hair just starting to protrude from the ferrule, as shown at the left. This gives more spring and strength to the brush. The belly, or thickest part of the hair, is the strongest part. The positioning of this belly, along with the type of hair and the treatment it receives in preparation for use, determines how well a brush will hold its shape and how much spring-back it will have.

Oil brushes are more slender; watercolor brushes are made with a bulge using the belly of the hair as shown below.

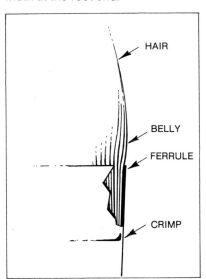

The best soft hair brush is the pure red sable. The hairs taper gently and come to a fine point. These hairs are cut from the tail of the kolinsky — an animal in the mink family found in Siberia and various parts of Asia. The fur of this animal's tail is selected because it has all of the required characteristics to make the finest brush of its kind.

After selection, the hair is combed by hand and any bent or misshapen hairs are removed. It then goes through a gentle heating process where any grease present is removed without losing the natural oils or destroying the hair's flex and resiliency. These hairs are sorted for uniformity of length and then formed into a brush by the hands of a skilled brush maker. They are set into the ferrule with a vulcanizing compound and crimped onto the wooden handle by machine.

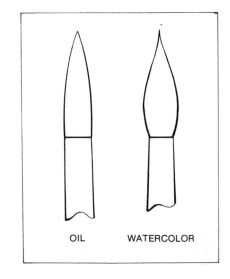

OIL WATERCOLOR

18

Filberts

A filbert of red sable can accomplish the same things as one of bristle, except the sable is more delicate and can draw a finer line and perform some very soft blends. It can also be used to apply a minute amount of paint to a small area because of the type of hair. Many different strokes are possible with this fine brush, but it should not be used to push large masses of paint around — that is what the bristle is for.

The filbert sable is available in a range of sizes, from 1/4" to 1" wide. Some manufacturers make larger, specialty sizes.

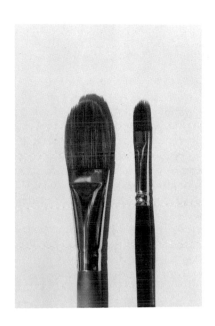

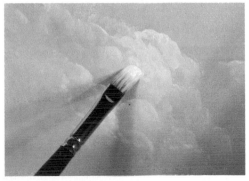

By thinning the paint and setting the tip of the sable filbert in a chisel edge, tiny circular stampings can be made for foam and wave action.

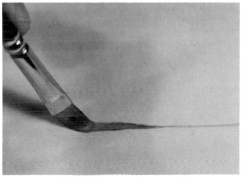

By drawing the brush sideways we can paint the light on a back wave. The downward curve carves the top of the dark wave. Blending the top creates a trough.

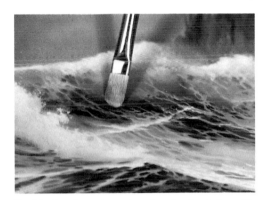

The sable filbert is capable of far more detail than the bristle filbert. The same techniques apply, but as shown here, the sable strokes are finer.

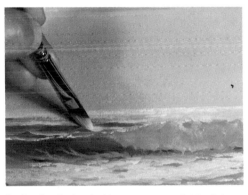

Thick and thin patterns can be painted with the sable filbert by turning it as you stroke. The lines are finer than those made with the bristle.

Brights

The hair in the sable bright, like the bristle bright, is shorter than the other sable and soft hair brushes of this rectangular style. The hair is the same as, or just a little longer than the width of the ferrule. Like the bristle in this style, this gives the brush more strength and adaptability toward detail and tiny areas of blending. The stiffness of the hairs being set deeply into the ferrule makes this an important painting tool. This stiffness allows brush marks and textures to be painted into the surface of the painting where desired. The strength of the bright also allows a larger load of paint to be worked than the more flexible flat does. The sharp corner of this brush is an excellent tool for detail. Also, because of the chisel at the end of the brush, it is capable of fine line work. The bright sable is available in a range of sizes, from 1/8" to 1" for general painting.

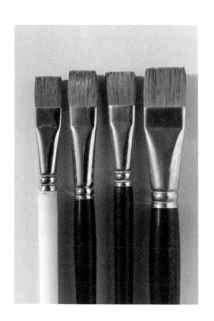

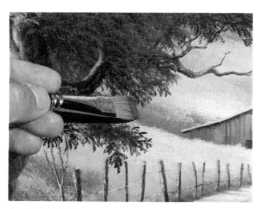

As with the bristle bright, using the corner of the sable bright creates the illusion of foliage. The sable is capable of very tiny, fine strokes.

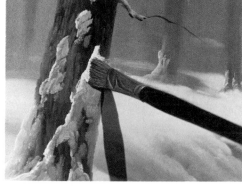

Loading the sable on one side and placing the paint to the outer edge of the snow makes a firm outside edge and a soft blend inside. This creates depth.

As shown here, a sable can draw a very fine line. The paint must be thin and the surface dry in order to accomplish this. The pressure used is light.

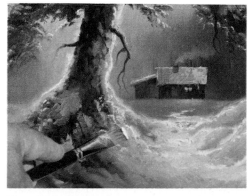

The sable bright will carry a good load of paint to the canvas and create important textures on the surface of the painting.

Flats

Like the bristle brushes, the sable and soft hair flats are far more flexible than the brights because of the length of their hair. The length is usually around one and one-half times the width of the ferrule. Much softer blends can be obtained with a flat and, because of the flexibility from side to side (and broadly), a very soft touch is possible. The flat does not have the clean, sharp corners of the bright when painting because of the hairs moving so much more. This is not a drawback, however, as this brush is an indispensable tool for gentle blends and soft manipulation of the paint. The flat is superb for wet-on-wet painting. A soft overpaint can be laid onto a wet underbase without plowing through and mixing the colors too much. It is not made for pushing large amounts of paint around because of its flexibility.

Flats are available in a range of sizes, from 1/8" to 1" wide for general painting.

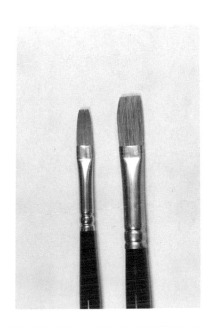

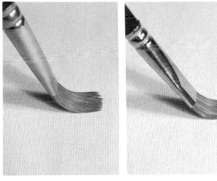

The photos above show the difference in the side flexibility of the longer-haired flat on the left and the shorter-haired bright on the right.

These photos show the difference in flexibility of the two brushes in a broad stroke. The flat on the left is far more flexible than the bright.

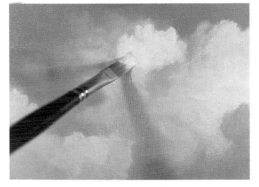

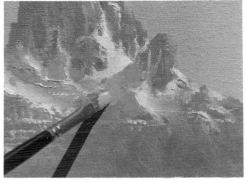

Because of this flex, the flat sable can be used to apply fresh white paint onto a wet surface without losing the strength of the white or plowing in.

As with the bristle flat, overpainting forms such as snow patterns on the side of a mountain is possible, but the effects with a sable can be finer.

Rounds (Pointed)

When discussing soft hair rounds, we must again take into consideration the variety of hairs available. Each works a bit differently. The hair used in the type categorized as "camel hair" has little or no memory for spring-back. Because of this, they are usually not considered a good oil painting brush. Brushes made of ox, badger, skunk, etc., are good substitutes for the expensive pure red sable when economy is a factor.

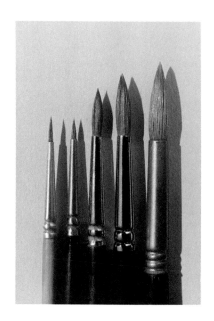

The round red sable oil brush has a long, gently tapered handle. The hairs taper from the ferrule in a slender manner. This brush has a delicate point and is capable of fine-line work. The pointed round is capable of a large variety of strokes depending on the pressure applied to the brush and the consistency of the paint.

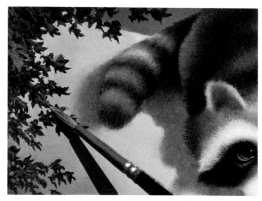

A very finely-pointed round is being used to paint the lighter parts of the leaves. Great detail is possible with a fine point and thin paint.

This smaller pointed round is used to place the highlight into the eye. This brush was used for some of the hair, and the fur and eye detail on the raccoon.

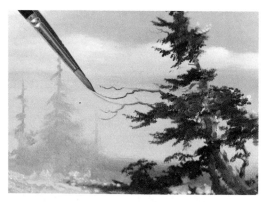

By thinning the paint and lightly drawing the brush to the side, little twigs and branches can be painted easily. The touch must be light.

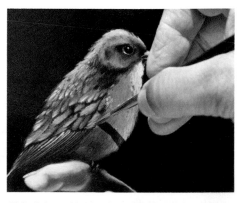

This little sparrow was painted entirely with the pointed round shown here. Wider strokes are possible by applying pressure; a light stroke gives fine lines.

Rounds (Blunt-End)

The blunt-end round brush is available in various hairs and will give broad blends while maintaining the soft touch of the pointed round. The hairs are simply set into the ferrule so as to make a more rounded end on the brush. This brush can carry a large load of paint. Also, when the tip of a pointed round wears down, the brush becomes a blunt-end round and is a valuable tool.

Blunt-end rounds are available in sizes from 1/16" and up. Pointed rounds are available in sizes from 1/16" to 3/8" ferrule width for general painting. There are some larger ones available at additional expense.

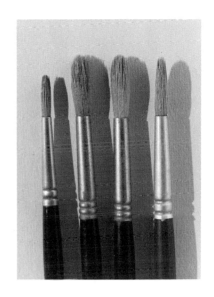

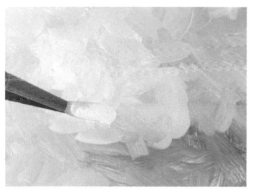

A blunt-end round is great for broad stroking and interweaving various colors. It is also capable of creating very soft blends when used dry.

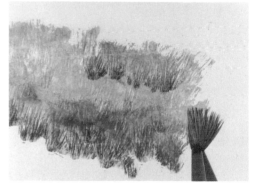

As with the bristle round, the sable can be pushed and rolled at the same time to create textures like those shown here.

Lesser Sables

There are a number of brushes labeled "sable" that are not made of pure red sable. These are either a lesser grade of sable hair or are made from ox, badger, etc. They are available in most styles of soft hair brushes and work well as a substitute for the more expensive pure red sable. They are also great for class-room experiments.

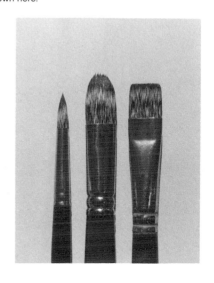

Special Purpose Brushes

Script, Liner, Rigging, Signature

The words "script," "monogramming," "liner," "rigging," "twiggy," "signature," and "scroll" all basically describe brushes (some blunt-ended, some pointed) that do all of those things and more. They can actually perform any job requiring a fine-line control. These brushes are available in natural hair of all types, blends of natural and synthetic hair, natural bristle, and synthetic bristle. They are valuable tools for ship painters for lines and rigging; landscape painters for twigs and small branches; portrait painters for hair detail; and for lettering in a script style. Although they are not a pin-striping brush per se, they have been used for this purpose.

The type and length of the hair or bristle determine what the brush will do. The longer and thinner the hair, the finer the point and resultant line. For a good thick-and-thin line variation, a slightly wider brush is needed. With care, one can obtain the same precise, thin line with the point of a larger brush as with a tiny, thin one. It is convenient to have several sizes. These brushes are available in sizes ranging from 1/16″ to 1/4″ ferrule width. There are some wider ones available, but these are not usually used for general painting unless large script lettering is added to the painting.

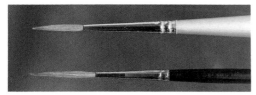

Two sizes of the script (or liner) are shown here. They can hold a good load of thinned paint and make very long lines.

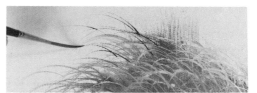

Here is an example of long grasses being drawn with the script brush. The paint should be thinned with medium and the stroke light, using only the tip of the brush.

Badger Blender

The badger blender is made of fine badger hair and is a necessity when a very smooth finish and blend of colors is required. This brush is round or sometimes triangular at the ferrule and opens evenly to a wider, flat end with no point. It is perfectly flat on the end so it can be used in a soft stippling or pouncing stroke to soften a blend between two colors or to feather out the edge of a glaze. By holding the brush perpendicular to the painting surface and gently tapping the surface of the painting, a graduation of color can be obtained, leaving no sign of brush strokes. It is used in the art of photo realistic painting and smooth portraits.

The badger blender is available in a range of sizes, from 1/8″ to 3/4″ wide at the ferrule.

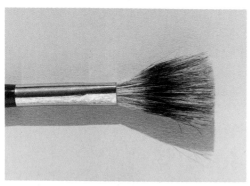

There are different sizes of badger blenders available. The one shown here is a #2. Remember, sizes vary with the maker. Choose the one you like.

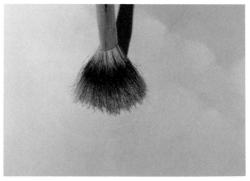

By tapping and turning the brush, a very soft-blended effect is achieved. All signs of brush strokes can be eliminated using this method.

Fan Blenders

There are a number of brushes designed to manipulate the surface of the paint after it has been applied to the canvas. These brushes are usually used clean and dry. Fan blenders are designed to do just that — blend colors together. Because the bristles are arranged in the shape of a fan, this brush allows for some soft manipulation of wet paint. The corners can be used in small areas and the complete end of the brush is used for larger areas. This brush is available in natural hair and bristles and in synthetic hair and bristles.

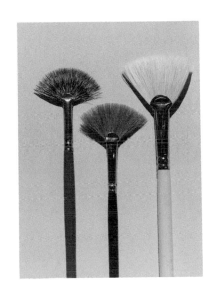

Care must be taken to be gentle of touch when using bristle, as it is firmer than soft hair and will leave a pattern of curved, fingernail-like marks on the surface if used roughly. A light dusting stroke is recommended. This brush was developed as a blender and not for the application of paint; however, many artists of today are using it as a paint application tool. The unique shape of this brush can be a drawback when used in this manner, as the uniform and monotonous texture of half-circles will conflict with the subject of the painting. Trees, grass, fur, and shrubs that are painted with this brush are easily spotted by the viewer due to the monotony of stroke. The brush is then categorized as a gimmick brush. When used correctly for blending, it is a valuable tool. The fan brush is available from various manufacturers in a wide range of sizes, from 1/2" to 3-1/2" brush width.

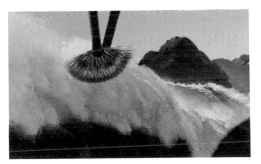

By lightly dragging the soft-haired fan blender up the wave, an extremely light blend is accomplished. A number of strokes may be required.

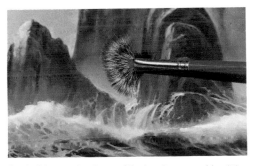

Capitalizing on the shape of the brush, we can blend the haze between the rocks without disturbing them. The stroke is to the right and up and off.

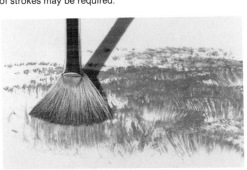

Using the bristle fan brush, a variety of textures is possible. Here, the brush is being stamped and dragged for various effects.

By dragging the sable fan brush through a wet glaze of color, the illusion of hair is created. The dry brush removes color, letting the light base show through.

Hake Brush

The soft white hair of the hake brush is so delicate that it can be used for soft blends that do not require the smoothness of blend obtained by the badger blender. It is also versatile as a paint application tool, even though it was originally designed to apply thin layers of priming gesso or varnish and as a general blender for both watercolor and oil. It is also used to paint the impression of such things as grass, bushes and other foliage, and a quick foam in seascapes. It is an inexpensive brush and a good workhorse. For blending, it should always be used dry with just the tips of the bristles lightly touching the surface. It should be wiped with a dry cloth frequently.

The hake is available in sizes from 5/8" to 4" wide. The most versatile size, in my opinion, is 1".

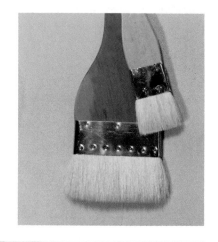

Whisping a dry hake brush across two wet colors results in a very delicate, soft blending of both colors.

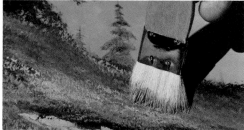

Here the brush has been well-loaded with paint and the spread of the bristles creates a texture that appears to be weeds, grass, etc.

Cat's Tongue

The cat's tongue is available in pure red sable, other natural hair, and synthetic hair. It is usually sold as a tole painting and craft brush, but it is a good specialty brush for the canvas oil painter, too. It is used for special loads of paint to make flower petals and such. The length and shape of the hair are a little more pointed than the filbert and resemble the tongue of a cat — hence the name. The width of the brush can be used for soft blends in small areas. Because of the fine tip, thin lines are possible. By changing the angle and pressure of the tip on the surface, a large variation in line width and pattern is possible. The cat's tongue is available in sizes ranging from 1/8" to 5/8" wide. Some manufacturers offer other sizes.

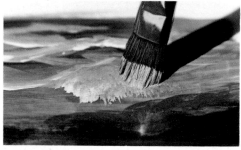

By stamping and pulling away, the effect is that of rolling surf. Some of those brushes are more pointed and must be pressed firmly.

By changing pressure on the brush, the thick-and-thin effect can be used to rough in leaves or other patterns.

Graining Brush

Graining brushes are made from many different types of hair and bristle, but a soft white bristle is most commonly used. Graining brushes are used to paint various wood grain patterns. The spaces between the gatherings of bristles is what makes these brushes special. They are available commercially or they can be made out of an ordinary brush by carefully cutting and removing the hair at intervals. Some artists have several brushes with different space widths for painting assorted grain effects. By twisting the brush and varying pressure on the tip, one can create many beautiful grain patterns. A large draftsman's horsehair brush can be used for massive wood grain panels.

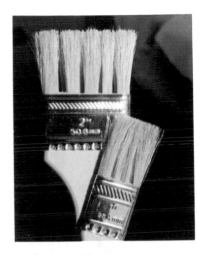

Graining brushes are available in sizes from 1″ to 4 ″ wide. Larger sizes can be special ordered.

The coarseness of the graining brush automatically creates a pattern that appears to be wood grain. The knot is painted with soft-hair rounds.

Here are two old brushes that have been made into graining brushes by cutting some of the bristles out. The finer the hair, the finer the wood grain.

Varnishing Brushes

There are several types of varnishing brushes; they are usually made from high-quality black or white hog bristle, badger hair, black or light ox hair, fitch hair, or synthetic hair. The price of these brushes varies, but the cheap, economy ones are not recommended. A brush of the highest affordable quality is best. There are, however, a few middle-priced brushes available that perform beautifully. A good varnishing brush is also handy for applying even coatings of primers like Gesso, or an oil underpainting white. Caution: make sure ALL Gesso is washed from the brush immediately or the brush will be ruined. A thin brush is more controllable than a thicker one. One reasonably-priced brush is a sign writer's cutter brush. This brush is thin of body and tapers to a controllable chisel edge.

The finest all-around duty brush is a 2″ to 2-1/2″ wide cutter brush of high quality soft white bristles. Varnishing brushes range in size from 1″ to 6″ wide. Some makers offer other sizes for specific techniques.

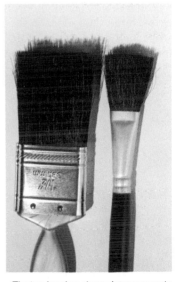

The two brushes shown here are made of black ox hair. The finer the bristle, the smoother the varnish.

Striping Brushes

On rare occasions an oil painter will need a brush that gives very long, fine lines like in pin-striping (an art form used to decorate vehicles). A striper brush is just the tool. The hair is usually listed under the trade term of camel hair, but it is usually made of squirrel hair. They are long and very controllable. The paint load on the brush must be very fluid so it will flow easily. After loading the brush, reshape the hair by laying it on its side and drawing it across dry newsprint. This aligns the hairs into the sword shape, so that long, controlled lines are possible.

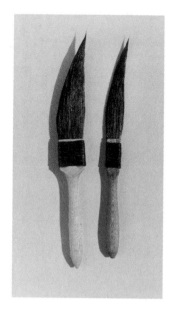

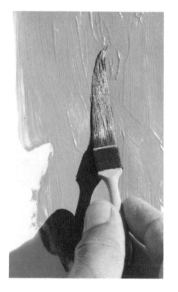

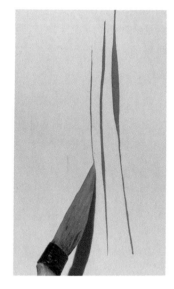

Load the brush by pulling it through wet paint in one direction as shown at the left. Do this several times.

By gently using the sword edge, very thin lines are possible. A bit more pressure creates a thicker line.

Sabeline Brushes

Sabeline brushes are made of the finest ox hair dyed to resemble the red sable, or a combination of pure red sable and other animal hair such as ox, badger, etc., or with synthetic hair. These brushes perform well with oil paint and are a less expensive line of tool to use and still have the feel and quality of natural, or mostly natural hair. They can be used for the same painting tasks as pure sable (see the example below). They are available in most of the styles in the previous listings.

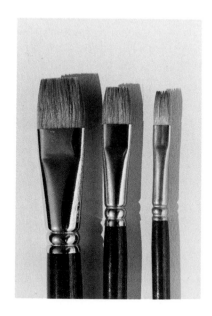

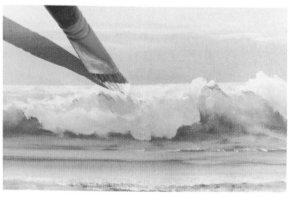

Synthetic Hair Brushes

All the brush styles discussed in the previous listings are available in synthetic hair also. These synthetic brushes are less expensive than the natural hair brushes, but do not perform as well as the natural hairs and bristles.

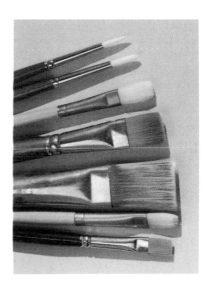

There is a large variety of names given to the types of synthetic hairs and bristles (many made of nylon) used to make these brushes. Many of the synthetic brushes work far better with water-base paint than with oils. Some have a tendency to flare-out at the end after being used with oil paint, no matter how carefully the user cleans and cares for them. When this happens, don't throw the brush away — capitalize on it by using it for a grass and shrub brush and for any other type of texturing it will perform. Again, remember that synthetic brushes work best with acrylic and other water-base paints. Natural hair brushes are best for use with oil paints.

The following is a list of brushes that make a good starter set (this list can be reduced, if desired, by selecting only those with an asterisk):

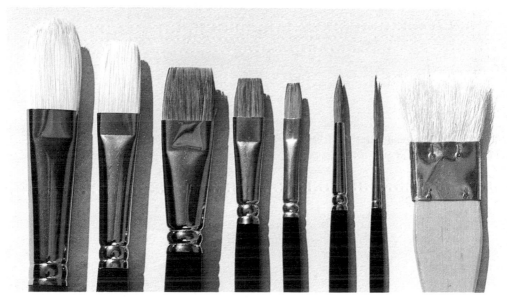

* 1 filbert-style bristle brush, approximately 3/4" wide

1 flat-style bristle brush, approximately 5/8" wide

1 bright-style sable or sabeline, approximately 3/4" wide

* 1 bright-style sable or sabeline brush, approximately 1/2" wide

* 1 flat-style sable or sabeline brush, approximately 1/4" wide

* 1 round-style sable or sabeline, approximately 1/8" ferrule width

* 1 signature/liner brush, between 1/16" and 1/8" ferrule width

* 1 hake or soft blender brush, approximately 1" wide

CARE AND CLEANING OF BRUSHES

After use, brushes must be cleaned thoroughly. Paint should never be allowed to dry in the hair or bristles. All color, and especially oil, must be removed from the brush. Just because no color is seen coming from the brush does not mean it is clean. It is the oil that is destructive to the brush as it clings deep in the brush next to the ferrule. This must be washed away because it is the oil that dries and polymerizes. This can cause the brush to spread and flare-out, destroying the shape forever. Once this happens, it is virtually impossible to correct and a good brush is lost.

The following steps are a good guide to successful brush cleaning:

1. Using a squeeze-and-pull motion, wipe as much paint out of the brush as possible with paper towels or cloth. Always pull the cloth straight away in line with the bristles, never sideways.

2. Wash the brush in the proper solvent — turpentine, mineral spirits, odorless art thinners, etc. Use two containers of solvent: one for the prewash and the other for the final clean wash after you are certain there is no more color coming from the brush.

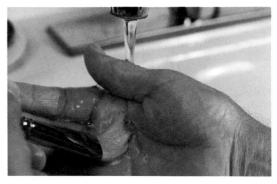

3. Using a mild soap (liquid or bar), wash the solvents out of the brush with warm running water. Even though all color was thought to have been removed from the brush before this step, more may be seen with the soapsuds. Using a circular scrubbing motion in the palm of your hand, continue this process as many times as it takes to be sure the brush is completely free of color and oil.

4. Use the same circular motion of scrubbing the brush in the palm of your hand under warm running water to remove all of the soap residue. It is important not to leave any of this residue in the brush.

5. Wipe the brush dry and reform the hair or bristles. Lay the brush on its side or hang it from the handle to dry. Never stand a freshly-cleaned brush on its handle end to dry because any residue of soap or oil that may have been left would be drawn by gravity to the ferrule, causing the bristles to spread. When the brush is completely dry, it can be stood on its handle for storage purposes.

6. After the brush is rinsed in step 4, an occasional application of a good hand- or skincream will restore the natural oils of the bristles. Lard oil, which is mostly olein, can also help restore natural oil. This treatment prolongs the life of the brush. Shape and leave the cream in the brush to dry. It will help the brush hold its form and will wash out when placed in painting solvents during its next use.

For long term storage, brushes are sometimes left suspended in an oil or solvent. This practice should never be employed for any length of time since a well-cleaned and dried brush will last far longer than those stored wet. If a brush is stored in this manner, the bristles must be totally submerged with no side or bottom pressure applied or the shape will be lost. Brushes individually wrapped in paper with the end folded so as to hold the shape of the bristles is one of the finest ways to store brushes for a long period of time. It is also wise to include a mothball or two.

It takes a great deal of effort to clean brushes after a long day of painting, but it is extremely important to discipline ourselves to do this. It is well worth the effort in terms of cost savings and, most importantly, in having a clean brush to begin the next session.

Studio Brush Washers

These washers are used for clearing color from brushes while painting. They are available commercially or can be made in the studio. A jar or tin can with a false bottom suspended about 1-1/2" from the bottom is sufficient. The bottom can be made of a smaller can with its bottom perforated and turned upside down inside the larger one, or a wire screen suspended on a can ring (a sponge is also good). Another easy one to make is to solder a metal hair curler onto two metal supports soldered to a tin can. Different sizes can be made from different size rollers. A washer is filled with turpentine or odorless mineral spirits. Excess paint is wiped from the brush with a paper towel or cloth. The remaining dirt is then washed from the brush and settles to the bottom. As it settles, the thinner again becomes clear and the brush can be cleared easily for another color application. The practice of pouring off the clear thinner and reusing it again is not a good one. The thinner appears clear and void of color, but it has absorbed the oil of the paint and should be discarded since it is the oil that emulsifies and clogs the brush. Some artists use two cleaners — one for precleaning the brush and the other for the final cleaning.

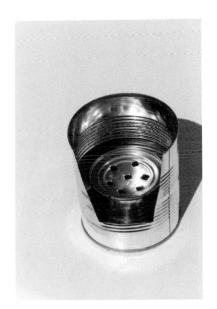

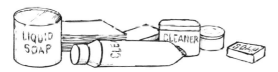

Brush Cleaners and Preservers

Several manufacturers make products for cleaning both wet and dried paint from brushes. Some have chlorinated and petroleum solvents in them. If there is any question, wear rubber gloves while using them. These products can work wonders on neglected brushes if the instructions are followed and we do not become impatient with the process.

Once oil paint has dried, it can no longer be returned to its original condition. It can, however, be dissolved in thinners and paint removers. It is not a good practice to use any industrial strength cleaners or removers on artists' brushes. They will not only attack the fragile bristles, but also the glue, causing the bristles to either shed or fall out completely. Some of these cleaners may be washed out with soap and water; some rinse from the treated brush with water only. Most all have some brush preservative in them, and several claim to stop the brush from shedding into the painting. These are available in various forms, from liquid solutions to soap cakes and tubes of gel. All are fine products and should be used thoughtfully. Always be aware that chemicals in any cleaners may cause a reaction if they come in contact with skin.

Hand Cleaners

Quite a number of good hand cleaners are available. They come in tubes, jars, and towel wipes. They remove paint from skin and fingernails. All are excellent and most restore the natural oils to the skin that are lost by coming into contact with thinners during painting. Some contain lanolin and are good at preventing dry-cracking. Individuals should be aware of the ingredients in these products in order to prevent any potential skin reaction because of personal chemistry.

PALETTE AND PAINTING KNIVES

There are basically two types of knives used in oil painting: one is the palette knife used for mixing pigments on the palette, the other is the painting knife used to create a painting. Although each type of knife is designed for a specific task, both are employed in the application of paint by some artists.

Palette Knives

The palette or mixing knife is available in two styles: a long, flexible flat blade, and a long, flat blade with an elevated handle to assist in keeping the hand from getting into the paint. Both have rounded tips and are slender. Wooden handles aid in gripping the knife. When mixing paint, these knives should be used with a gentle, kneading stroke — not a stirring motion. Care must be taken not to over-mix the colors no matter which knife is used. The elevated blade is the most popular.

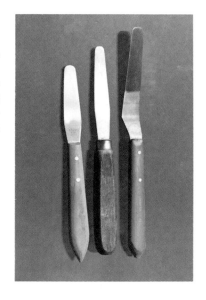

Painting Knives

Extremely fine works of art have been created with a painting knife. Painting knives are made in many shapes, styles, and sizes. Some artists even alter these to create a "custom-made" knife. A good painting knife must be thin, flexible and sensitive to the touch. These blades are made of hand-tempered steel and are usually all one piece, but sometimes soldered or welded to a long, thin handle. Knife painting is fun and can be used to accomplish an entire painting or intermingled with brush work for effect.

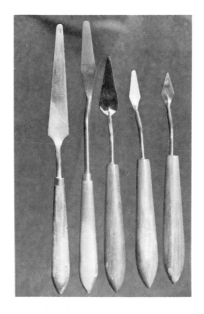

The most versatile style of painting knife, in my opinion, is tear-shaped with a small rounded tip. There are no sharp angles to accidentally dig the canvas. The more a knife is used, the more flexible it becomes. The edges become razor sharp after long periods of use, so wipe these older knives with care. Very soft blends are possible with a painting knife. The flat-style palette knife is used by some painters as a painting knife, but the straight attack to the canvas can cause harm to the primed surface if care is not taken.

Any painting knife must be flexible toward the tip for manipulation of paint in small areas. No matter which knife is used, in today's terminology this art is always referred to as "palette knife painting."

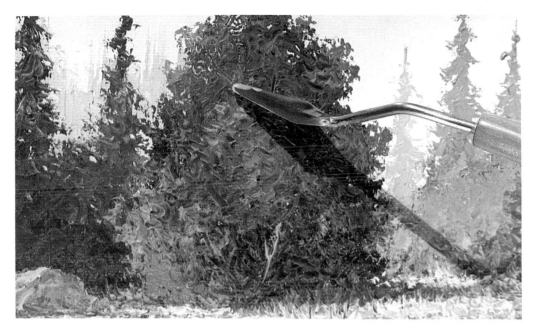

These two paintings were accomplished entirely with a knife. In the one above, the details are being painted on with a small painting knife. By loading the tip of the knife, the paint can be tapped onto the under-color. Where detail is required, the paint is left on the surface. Softer areas are blended by pressing harder.

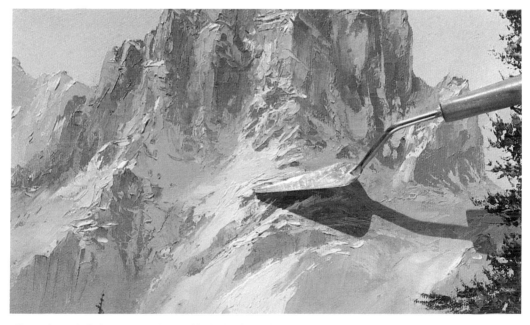

Here, a larger knife is used to apply the white highlights to the snow. Notice that even in knife painting the direction of stroke must follow the shape of the object being painted. As with the brush, we are drawing with the knife. Use a dry knife to make the soft blends.

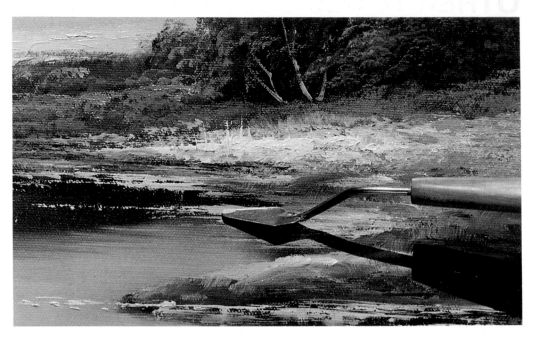

By loading the edge of the knife and placing it against the canvas, we can paint more linear as in the grey scum along the bank. Gently raise the bottom edge of the knife and draw it sideways. It works both right- and left-handed. The small light yellow grasses are made with quick, upward strokes of the tip of the knife.

Here we can see that heavy blends are possible by raising the leading edge of the knife and gently dragging the trailing edge. This is an example of a fairly rough blend, but with care, very soft clouds can be painted and blended into a delicate sky. Be gentle of touch.

OTHER TOOLS USED FOR PAINT APPLICATION AND MANIPULATION

The oil painter has been known to use any tool that will create the desired effect and not alter the permanence of the paint. Here are a few examples:

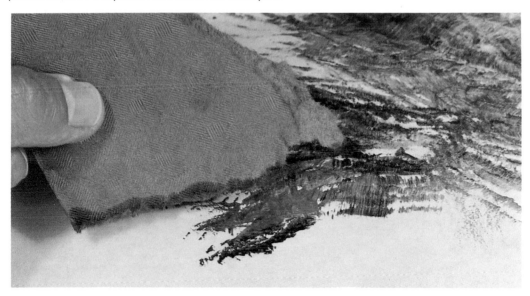

Heavy Desk Blotter Paper: This paper can be used for textural effects by using either the torn edge or straight side. Either way, paint is pulled away or applied, leaving a textured effect.

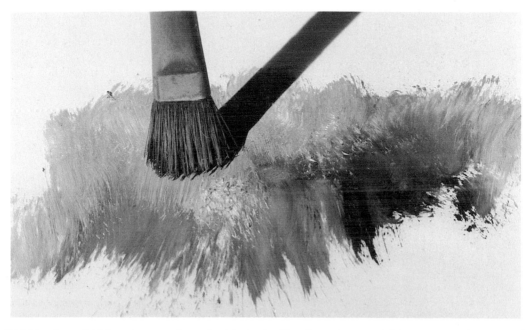

Old Brushes: Old brushes can be valuable tools. Use them for special textures such as wood grains, grasses and foliage. They can also be used for textured stippling.

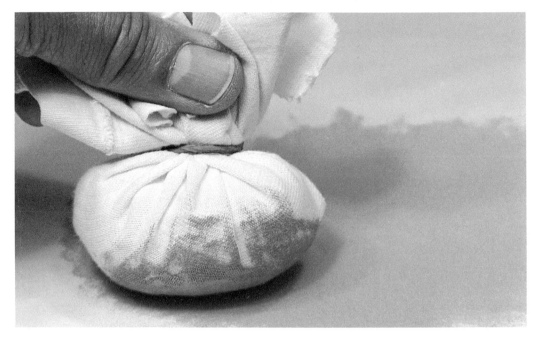

Dabbers: These are made of select cheesecloth and filled with cotton. They are used when applying color or glazes by dipping the dabber lightly into the paint or glaze. The thickness of application can be controlled and graduated into an extremely soft blend. Use a gentle tamping motion. The dabber shown above is made of a lint-free cotton material.

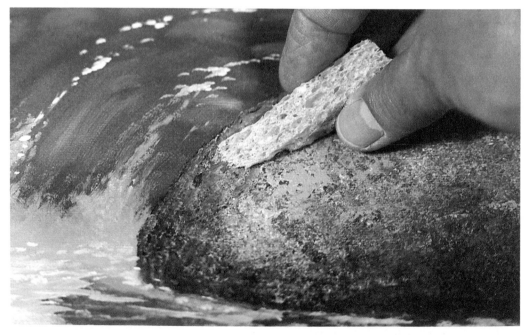

Sponges: Soft cosmetic sponges and inexpensive synthetic household sponges make good texturing tools. One example is the grain of a granite rock obtained by overlapping several layers of color and textures using sponges. There are other applications; do some experimenting.

Citrus Peel: The rind of an orange, lemon, grapefruit, etc., can give some interesting effects. In some manipulations, it resembles the skin of an aging person. Several overlapping applications resemble rock surface textures.

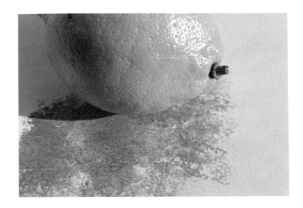

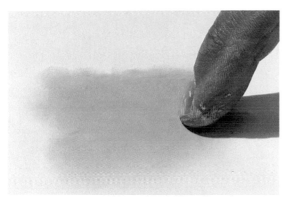

Fingers: Fingers are great painting tools — not for the application of paint, but for the manipulation of it. By using the end of a finger in a pouncing, stippling manner, a soft graduation of color values and blends between colors can be achieved. Also, there is no better identification mark in your painting than your fingerprint!

Sticks, Twigs: The art of using sticks and twigs as paint application tools is ancient. Some artists feel that the use of a twig automatically produces an atmosphere that is naturally conducive to painting tree limbs and twigs. Dip a slender twig into the paint and twist it while drawing it across the surface. The happenings are accidental, but in many cases, beautiful.

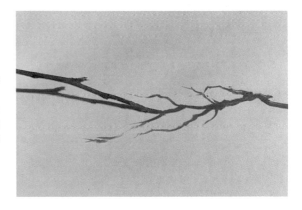

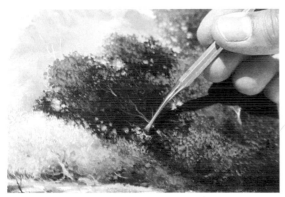

Old Dental Tools: These make good scraping tools. Holes in trees can be created by gently scraping with a dental pick. Care must be taken not to press too hard and dig into the priming or support. These tools work best when painting on a smooth surface such as a primed processed wood panel.

OIL PAINTS (Ready-To-Use)

Oil paints are made up of pigments suspended in vegetable oils that form a tough and lasting film. By absorbing oxygen from the air, polymerization takes place and the end result is dried oil paint. Once dried, it can never be returned to its original condition. Of the vegetable oils that fall into the classification of "drying oils," there are a few that are favored for making artists' paint for a number of reasons. Here are some important ones:

> The oil must surround the pigment, protecting it from atmosphere, moisture and any other materials that may prove harmful, including other layers of paint.

> It must allow the pigment to flow and be applied evenly.

> It must be adhesive, yet controllable.

> It must be clear so as to enhance the color of the pigment in it.

> It must resist becoming brittle with age.

> It must resist becoming discolored with age.

The following oils are the ones most used in making artists' paint. They are listed in order of importance and use. They are also used in the manufacture of painting mediums (discussed later):

> Linseed Oil (cold-pressed)

> Alkali — Refined Linseed Oil

> Sun-Thickened Linseed Oil

> Poppyseed Oil

> Safflower Oil

> Walnut Oil

Artists' oil paints are available in three common sizes: "student," "studio," and "one pound." The most widely used size is the "studio." These sizes are determined by industry standards, but today some manufacturers are producing other size tubes for their particular lines. The standard size "studio" tube is 1" x 4", the "student" being smaller and "pound" larger. All tubes are filled from the bottom and then folded and crimped. The "student" size is very convenient for travel and painting safaris because of its compactness.

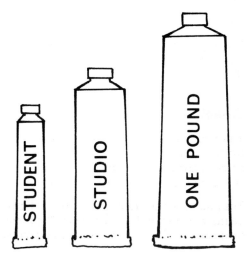

38

Oil Paint Colors

There are no hard and fast rules written into industry paint standards for variations in the same named color. There are, however, restrictions in the areas of tinting strength and ingredients. These restrictions serve to exercise some degree of control. Colors vary slightly from one manufacturer to another. For instance, a Naples Yellow made by one manufacturer may be light and vibrantly yellow while Naples Yellow by another is warmer and deeper. This can be frustrating in some ways, but beneficial in others. The variations in colors offer a larger range to choose from — one manufacturer's red, another's yellow, etc.

Many manufacturers produce several lines of paint, and the colors will vary from line to line. For instance, a Cadmium Orange in the "student" line may be a little more red than the Cadmium Orange in the "studio" line, even though they were produced by the same manufacturer. The same theory is true of a third or more lines that may be produced.

It is always best to begin with a small range of colors. However, due to the ingredients, there are certain colors that cannot be obtained by mixing the three primary colors of yellow, red, and blue. Because of this, the artist must select which colors are needed for each painting. One color will appear rich and lively in one instance, yet dull and muddy when used in another. Select the colors that appear nearest to the ones needed and then change them to the desired color by mixing with the other colors in the palette. It is amazing just how many colors can be obtained from just a few. (See *"Color and How to Use It"* in Walter Foster's Artist's Library Series.)

The following is a list of colors that most manufacturers offer:

Hansa Yellow	Cadmium Red Medium	Pthalocyanine Blue	Light Red
Lemon Yellow	Cadmium Red Deep	Permanent Green Light	Venetian Red
Zinc Yellow	Rose Madder	Pthalocyanine Green	Indian Red
Cadmium Yellow Pale	Alizarin Crimson	Viridian	Terra Rosa
Cadmium Yellow Light	Brown Madder	Sap Green	Ivory Black
Cadmium Yellow Medium	French Ultramarine Blue	Chrome Oxide Green	Mars Black
Cadmium Yellow Deep	Ultramarine Blue	Green Earth	Lamp Black
Naples Yellow	Permanent Blue	Mars Yellow	Titanium White
Cadmium Orange	Cobalt Blue	Raw Sienna	Zinc White
Yellow Ochre	Cerulean Blue	Burnt Sienna	Flake White
Cadmium Red Light	Manganese Blue	Raw Umber	
Vermillion	Prussian Blue	Burnt Umber	

In addition to this list, each company makes colors that are labeled with their own names and are referred to as "house" names or "proprietary" names. Good examples of these are the colors derived from copper pthalocyanine.

Quality

The best quality paint will have a good balance of oil and pigment. The lack of fillers also adds to the high standard of quality paint. Only the right combination of pigment, oil and additives (for preservation and consistency) makes the best quality paint. The most desirable consistency is a soft, buttery paint that is workable, yet still has the strength to cover or blend.

The price of a paint reflects the cost and quality of the ingredients used to make it. Student grade paints will contain far more inert fillers than professional quality paints. It is best to buy paint manufactured by well-known, proven companies. Always buy the best quality affordable.

Blacks

Artists' oil blacks are manufactured from a number of sources: carbon, charred vines and vegetable matter, charcoal, charred animal bones, and so forth. Because of this, the artist must not think that "black is black," and that's it. Each black is different and mixes with white and other colors differently. The viscosity and drying rate of each is also slightly different due to the individual makeup of each color.

To visually test each black so you can place it into your own category of warm/cool, strong/weak, and hiding power (ability to cover other colors when painted over them in a thin coat), try the following tests:

Place a small (exact) amount of each type of black into a larger (exact) amount of Cadmium Yellow Light. Notice the different greens that result with each black. Repeat the same exercise using Lemon Yellow and record these results. Next, follow the same routine using Titanium White. You will see the subtle differences in the blacks right away. This knowledge is important in order to know which black to select for a particular task. Most manufacturers offer only Lamp Black, Ivory Black (which is most commonly used), and Mars Black. In some instances, a different black with a "house" brand name is offered. (See *Color and How to Use It* in Walter Foster's Artist's Library Series.)

Whites

There are subtle variations in the whites just as in the blacks. The most common whites are Titanium White, Zinc White, and Flake White (which is basic lead carbonate and very poisonous). Flake White is the warmest of the three and will produce the warmest appearing grey when mixed with the same black.

Repeat the exercise used to test blacks by adding a small (exact) amount of Ivory Black to a larger (exact) amount of each white and notice the difference. Repeat the same exercise using a speck of Cadmium Red Light and still another exercise using a speck of Ultramarine Blue. The differences will be subtle, but they are definitely discernible. Record these in notes for future painting references. There are also other whites available under "house" brand names and they, too, will vary slightly and are worthy of repeating in these tests. Whites are available in studio size and larger tubes from various manufacturers.

The following is a list of suggested "ready-to-use" colors that make a good starting group:

Burnt Umber	Cerulean Blue	Lemon Yellow
Alizarin Crimson	Cadmium Red Light	Ivory Black
Ultramarine Blue	Cadmium Yellow Light	Titanium White

Fast-Drying Oil Paints

Manufacturers of artists' oil paints try to remain within the limitations of standards for drying. They also try to regulate the drying rates of all their colors to make them compatible with one another. This is accomplished by the addition of driers to colors that normally dry slowly, and slower drying oils to colors that normally dry faster. These manipulations are kept to a minimum in order to maintain the quality of the color.

There are fast-drying oil paints available from both European and American manufacturers. Some dry almost as quickly to the touch as acrylic paints, while others will become dry in about six hours. They are made with synthetic resins known as "alkyds." These paints can be intermixed with the normal palette of colors, but care must be taken to prevent uneven acceleration of drying in isolated areas, leaving the rest of the paints to dry more slowly.

The individual artist can manipulate the drying rate of paint in the studio by simply using commercially available driers (see Siccatives, page 44), but again, this practice should be done thoughtfully and sparingly.

Dry Pigments

For those who wish to experiment with pigments or make their own colors, pigments in a dry powder state can be purchased. It is very interesting and exciting to originate colors from these dry pigments. The pigments may be mixed with oils, oil and turpentine, varnishes, etc. They are available in several grades of grain and are made of the finest ingredients made for oil painting. But, many producers will not guarantee that the color will match the colors on their ready-to-use paint charts. This is understandable due to their lack of control as to

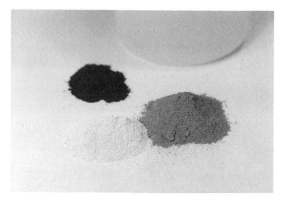

how the pigments will be used in individual studios. The fine grain pigments are helpful in enhancing colors, strengthening the tint of colors and adding to other colors to create new ones. When added to oil or other mediums, some of these dry color powders will darken. This darker color is close to the appearance of the final color when dried. They are available in jars and cans from two fluid ounces and up.

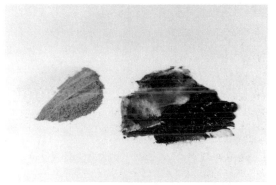

In the photo to the right, the dry blue powder has been mixed with pure linseed oil. Powders become darker when wet, whether with oil or water. The use of dry powder pigments allows us to mix only what we need. The powders will store indefinitely as long as they are kept dry.

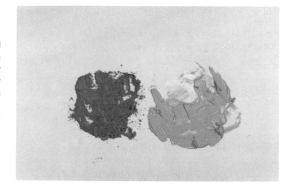

Here the dry blue powder has been mixed with white oil paint. Notice that by adding white, the lightness of color returns. Any degree of lightness is possible by simply adding more of the white. These dry powders are usually added to oil, but as you can see, they mix well with paint. If the mix becomes too dry, simply add linseed oil to thin.

Oil Paint In Stick Form

Oil colors in stick form are manufactured with ingredients that dissolve in turpentine. These colors can be applied directly to the canvas or painting surface and then blended with a brush and turpentine to the desired effect. They are used for location sketches as well as complete paintings. Colors may be liquified by placing them in a small dish with turpentine. They can then be painted on with a brush. Some artists use oil sticks or oil pastels for preliminary sketching on canvas. When used in this manner, care should be taken to keep the color film very thin and not allow a buildup of pigment that can undermine the subsequent layers of oil paint.

OILS AND MEDIUMS

These oils and mediums are used primarily to thin the consistency of oil paint and to act as a clear carrier drying solution in the art of transparent glazing. They are also used in some instances to advance or slow the ·drying time of paint. Linseed oil and products derived from processing linseed oil are the most desired and proven successful. Other oils are used, but each has some characteristic that makes it slightly inferior to linseed oil.

There are many types of painting mediums available. Frequently, manufacturers have concocted their own formulas for mediums produced only by them and have given them "house" names. The different types and amounts of mediums do not have to be complicated. Just remember that these mediums are made to assist you in the manipulation of paint. Some mediums dry fast; some dry slowly. It all depends on which oil is selected and how much processing each oil has undergone, in addition to what drying agents have been added.

You might wish to experiment and make some mediums of your own. I have included some recipes at the end of this section that I have used over the years with success. Mix some and try them. It is very satisfying to use a medium that you have mixed on your own for a specific task.

The following is a list of mediums most commonly used and available, as well as a brief description of the intended use of each:

Linseed Oil

Linseed oil is obtained from the flax seed under pressure with and without heat. It has proven with age to be the finest oil for use in painting mediums. It is the basic ingredient for many other painting oils, such as stand oil and pale drying oil.

Cold-Pressed Linseed Oil

Cold-pressed linseed oil is made from raw oil that has been aged and undergone an involved filtering process. After this processing it resists becoming brittle with age better than other oils. It increases gloss and the transparency of paint. It is used to thin paint and in the formulation of other, more complex mediums. It also slows the drying rate and reduces brush marks in thinly applied layers of paint. It can be thinned with rectified turpentine or rectified petroleum thinner, but caution should be taken not to over-thin, as this can weaken the binding quality. Cold-pressed linseed oil works well when used pure, but drying will accelerate with the addition of any volatile solution.

Refined Linseed Oil

Most of the oil labeled "Refined Linseed Oil" or "Alkali Refined Linseed Oil" has been extracted from the flax seed under pressure (as is cold-pressed), but with heat or steam added to extrude more oil. They are good grades of linseed oils, but weaker than the cold-pressed oil in body and strength. The resistance to becoming brittle is much lower than with the cold-pressed oil. They are also considered a less clean oil.

Refined linseed oil is used for thinning the consistency of oil paints. It also enhances gloss and transparency, slows drying rates and reduces brush marks in thinly applied paint. It may be thinned with rectified turpentine or rectified petroleum thinner, but the same caution as above applies to over-thinning.

Sun-Thickened Linseed Oil

Sun-thickened linseed oil is made by mixing raw linseed oil with water and then treating it with sunlight for a period of time. The result is a thickened, pale-colored, syrupy medium that dries faster than linseed oil and stand oil. It accelerates drying time and creates an enamel-like quality to oil paints, aids in the flow and transparency of paint where desired. It adds gloss and is less prone to yellowing than untreated linseed oil. It resists cracking with age and is best used when thinned a little with rectified turpentine or rectified petroleum thinner. It is a superb oil for medium formulations, general painting and transparent glazing.

Stand Oil

Stand oil is made by treating linseed oil with heat until slight polymerization occurs. The result is a very thick, pale to amber medium that must be thinned with rectified turpentine or rectified petroleum in order to be used easily. When thinned, stand oil improves the gloss and flow of paints. It will slow drying times depending on how much it has been thinned. It produces a flexible, but tough film that is superior in resisting yellowing and cracking with age. Stand oil is one of the most desired mediums for general painting, but especially in the use of transparent glazes. This oil flows so beautifully that it lays down smoothly and when dry, hides any trace of brush marks. This alone makes it a valuable medium for transparent glazing.

Pale Drying Oil

Pale drying oil is made by treating and refining linseed oil. The result is a slightly thicker oil than linseed oil. It is very pale in color and will thicken paint slightly. It improves the flow of paint and accelerates drying time slightly above linseed oil. Do not overuse this medium as some contain driers which can cause cracking. Pale drying oil resists yellowing and cracking with age when used sparingly and can be thinned with rectified turpentine or rectified petroleum thinners. The previous thinning caution also applies.

Poppy Oil

Poppy oil is pressed from the seeds of the poppy. It is a very pale oil with non-yellowing qualities that are superior to linseed oil, but with a greater tendency toward cracking and becoming brittle with age. It is used for mixing whites and light colors and general painting. The best variety is cold-pressed, but it is difficult to find. It is available in cold-pressed and refined forms, and different degrees of thickness. It is slower drying than linseed oil. Poppy oil thins the viscosity of oil paint and slows drying rates. It can be thinned with rectified turpentine or rectified petroleum thinner. Previous thinning caution also applies.

Walnut Oil

Walnut oil is obtained from walnuts. This oil will thin the consistency of oil paints and retard the drying time at approximately the same rate as linseed oil. It does not yellow as much as linseed oil, but has weaker film which makes it inferior. The best variety is cold-pressed, but it, too, is difficult to find. It often becomes rancid during long storage. It can be thinned with rectified turpentine or rectified petroleum thinner. Previous thinning caution also applies.

Safflower Oil

Safflower oil is made from the seeds of the safflower plant. It is a pale-colored oil that dries more slowly than linseed oil. It will thin the viscosity of oil paint and resists yellowing. It is flexible when dry, but weaker in body than linseed oil, causing a tendency to become brittle upon aging. It is used for mixing whites and light colors and can also be used for general painting. It can be thinned with rectified turpentine or rectified petroleum thinner. Previous thinning caution also applies.

Copal Painting Medium

True copal is a fossil resin from coniferous trees. It is similar to the resin that made up the old amber beads of yesteryear. This copal resin is found and mined in the Congo. It is used in the making of varnish and is an important ingredient in copal oil painting mediums. The true copal is very expensive and becoming scarce. Because of these and other factors, in the mid-1980's the makers of artists' oil mediums suspended the production of the true copal mediums. Many are now producing synthetic painting mediums using synthetic resin. These synthetic mediums are being marketed under different spellings of the word "copal." None of these are composed of the old and important painting medium made from true Congo copal.

Copal painting mediums are a concoction of differing recipes of copal resin (synthetic or real), stand oil, and rectified turpentine or rectified petroleum thinners. These mediums are used to thin the viscosity of oil paints. They slow the yellowing of oil paints and create a flexible, elastic film that resists becoming brittle with age. They are used for general painting and applying transparent layers of glazes and are a good wet-in-wet painting medium.

Boiled Oil

Boiled oil is linseed oil that has been treated with driers and heat. It accelerates the drying of oil paint and acts as a thinning agent. The color is usually darker than linseed oil and should be used with darker colors.

Venice Turpentine

Venice turpentine is not really a turpentine as such; it is a painting medium. This natural resin is taken from the larch tree and is used as a paint thinning medium. It retards drying and aids in the flow of color. It is used in the formulations of glaze mediums and enhances the gloss. It has a tendency to yellow.

Oil of Cloves

Oil of cloves is used very sparingly to retard the drying of oil paint. It allows the paint to flatten out. It must be used with caution as it can weaken the paint film and underpainting. It can be obtained from pharmacies, but is not commonly packaged today for artists' use.

Siccatives

Siccatives are substances that promote or accelerate drying. They are added to painting mediums for different degrees of drying times and paint manipulation. Cobalt dryer (Linoleate), manganese driers, and Japan drier are the most common; all are available from your local art supply store or can be ordered. They must all be used with caution as they can have adverse effects on the paint film if used too heavily.

Medium Recipes

All of the foregoing oils and mediums can be used for blending, mixing, the preparation of other medium recipes, and the glazing of oil paints. Some companies carry the refining processes further, ultimately labeling the resulting mediums and oils with "house" names.

The following recipes are intended as an introduction to mixing your own mediums. They are very simple in makeup and are good painting and glazing mediums. I have used and tested each of these for more than 25 years — all have proven durable and resistant to cracking and yellowing. Have fun and experiment! Be very thoughtful when mixing; try not to shake the solutions because air bubbles that are formed in the solutions will accelerate the drying and slow the process. Store all of these mediums in closed containers allowing as little head room as possible.

General Painting and Glazing Medium 1:
(Good glazing medium, dries faster than linseed oil)

1 part stand oil
1-1/4 parts rectified turpentine or rectified petroleum thinner

Painting and Glazing Medium 2:
(Heavy-bodied glazing medium)

3 parts stand oil
1 part rectified turpentine or petroleum thinner

Painting and Glazing Medium 3:

(Faster drying/good glazing medium; store in closed jar with as little head room as possible)

2 teaspoons odorless thinner
2-1/2 teaspoons stand oil
Approx. 10 drops from an eyedropper of cobalt drier (Linoleate)
1/2 teaspoon Damar varnish

Painting and Glazing Medium 4:

4 teaspoons turpentine
1/2 teaspoon Damar varnish
3-1/2 teaspoons stand oil
10 drops cobalt drier (Linoleate)

Oil Painting Medium 5:

(Simple, fast-drying, general painting medium; can be thinned a little more if necessary)

3 parts sun-thickened linseed oil
2 parts turpentine or thinner

Feel free to manipulate these formulas to a degree, but be cautious not to over-thin and lose the body.

Gel and Paste Mediums

These mediums are manufactured by several companies. They are thick and usually come in tubes. They can be mixed with oil paints to either thicken the paint and hasten the drying, or to make them buttery and workable. They are good for textural effects, glazing and detail work. Most gels are composed of a thick resin base and are resistant to yellowing and cracking. Some increase and some reduce gloss. Most increase transparency of the paint. They may be thinned with turpentine or petroleum thinners if necessary.

WAXES (Encaustic Painting)

Waxes are used in the art of "encaustic painting." This means that dry powder pigments are mixed with hot wax, blended on a warm palette, and applied to the painting surface. They can be manipulated with the aid of warm painting knives; brushes are useful too. Upon completion, the painting is usually subjected to heat lamps for a "burning in" of the material. This causes a blending and partial smoothing of the surface, depending on the thickness of the wax. It results in a beautiful illusion of glazes and depth in the work. It is great fun, but not for the impatient. A number of commercially prepared waxes and instructions for their use may be obtained from your local art supplier. They are quite inexpensive.

THINNERS/SOLVENTS

Thinners and solvents are used in painting mediums, for thinning oil paints, and for cleaning tools. They are flammable and should be used with adequate ventilation.

All of these thinners/solvents should be used sparingly in thinning oil paints! Any thinner can wash away the oil base and binders if overused. This leaves dull spots in the finished painting. It is generally recommended that they be used for thin layers of underpainting only, as overuse throughout the painting can cause cracking and chalking.

Turpentine

Turpentine is a solvent made by distilling the pitch of pine trees. It has a number of uses in oil painting and is available under several names: Pure Gum Turpentine, Gum Spirits of Turpentine, Turpentine, Rectified Turpentine, Refined Turpentine, etc. The more highly-refined the turpentine, the less residue it leaves when dry.

Turpentine is used to thin the consistency of oil paints and sometimes for cleaning equipment. The slight gummy residue deposit from drying or evaporating can be harmful to brushes if left to accumulate with each cleaning. Turpentine is excellent when used in the formulation of painting mediums and is one of the oldest known for such uses.

Oil of Spike Lavender

Oil of spike lavender falls into the category of essential oils. It is distilled from the lavender plant. It has many of the same characteristics as turpentine, but is slower drying and leaves a bit more gummy residue. For artists who cannot tolerate the smell of turpentine, this fragrance may be more pleasant. It is used in the same manner as turpentine.

Petroleum Thinners

Petroleum thinners are made by distilling petroleum. They are available under a number of different labels, such as: Rectified Petroleum, Mineral Spririts, White Spirits, and Odorless Thinner. (Some infer that they are derived from turpentine and made odorless, but they're not.) Petroleum thinners evaporate and do not leave the gummy residue of turpentine. They can be used in the same ways as turpentine. The more highly-refined thinners are odorless.

VARNISHES

Varnishes are made of resins — either natural or synthetic. These resins are combined with a volatile solution of either turpentine or petroleum thinners to form a workable solution. The varnishes listed here fall into two categories: working varnishes and final protective varnishes.

Working Varnishes

These varnishes are employed during the production stages of painting. Each varnish is designed to perform specific tasks involved with the mechanics of building and completing an oil painting. Each is capable of producing very beautiful results if used for the purpose intended.

Damar Retouch Varnish

Damar retouch varnish is used as a working varnish during the production of an oil painting. Thin coatings are either sprayed on, or brushed on to refresh the color in dry, dull, sunken spots. Damar retouch varnish also creates a bonding surface for the next application of paint or glaze. It is a natural resin harvested from trees in the East Indies (a small amount of stand oil has often been added for elasticity). Dry, dull colors will appear wet again, but care must be taken not to create a buildup in any one area. This varnish does not stop the absorption completely, so it should not be used as final varnish. It produces a gloss, but over a period of time this gloss will dull. It is available in spray cans or in bottles (to be applied with a brush).

Synthetic Retouch Varnishes

These varnishes are made of synthetic resins and are intended to be used the same as Damar retouch varnish. Many are labeled with "house" names and are also available in both liquid and spray can forms.

Mixing Varnish

This varnish, of either natural or synthetic resins, is intended for use in formulating painting mediums. It enhances the transparency of the medium and accelerates drying. It should only be mixed with mediums of thick oils, not just linseed oil, as it will weaken the final paint film. Damar is the most widely used varnish for this purpose and is available in bottles.

Isolating Varnish

This varnish is intended to isolate one layer of paint or glaze from the next layer. It should be composed of a resin that will not dissolve easily by the application of thinners or turpentine. (This type of varnish is sometimes referred to as "nonremovable varnish.") Natural Copal varnish was considered one of the finest, but since it is no longer available, artists are substituting varnishes made with alkyd resins. Any of these must be applied in an extremely thin coat. They may be thinned with turpentine or petroleum thinners. Some artists use a varnish that is actually made of a shellac base to be thinned with alcohol. It is unwise to use this heavily or in multiple layers because shellac will darken and yellow with age.

Several manufacturers are producing varnishes made with tung oil. They are water and heat resistant and are made for the art of tole painting; they should be used only in a few, extremely thin layers, if at all, as they yellow with age. They should not be used for canvas painting.

Final Protective Varnishes

These varnishes are intended to be applied in a thin layer over the entire painting surface when completely dry. Some manufacturers recommend a full year's drying time depending on the climate and density of layers of paint. A thinly-layered painting will dry faster than a heavy, thick painting and can be varnished sooner. Care must be taken, however, to insure that the painting is completely dry. Incomplete drying or moisture caught between the paint layers will cause mold to grow. This is detrimental to the painting surface. The best way to apply any final protective varnish is to warm both the varnish and the painting surface with sunlight or similar means. This will help guarantee the evaporation of any moisture that may have settled on the surface. It also warms the surface, making it more receptive to an even coating of varnish. The varnish must be applied as thinly as possible; it is to act as a protective coating only, which can be removed if necessary to restore the painting. Apply it with either a brush or spray.

All final protective varnishes are available in gloss or matte finishes. Matte finish is produced by the addition of wax in the varnish and results in a slightly softer, yet durable film. They can be thinned with turpentine or petroleum thinners.

Damar Final Varnish

This is the same natural resin discussed under "Damar Retouch Varnish." Here, the varnish is manufactured for final coatings and is to be applied as directed above. It is available in both liquid and spray can forms. Liquid can be thinned with turpentine or petroleum thinners.

Mastic Varnish

This varnish is used as a final protective varnish and is made from a natural tree resin different than Damar. It is harvested from trees in the Mediterranean. It will mix with turpentine and alcohol, but not with petroleum thinners. It brushes well and will flow and level easier than Damar, but it does have a greater tendency to yellow and crack. Generally, Damar is preferred over mastic. Mastic varnish is available in liquid form in small bottles from two ounces or more by order.

Synthetic Final Varnishes

There are numerous synthetic final varnishes under various "house" names. They are also offered under the labels of Picture Varnish, Final Varnish, etc., and are available in both liquid and spray cans. Liquid can be thinned with turpentine or petroleum thinners.

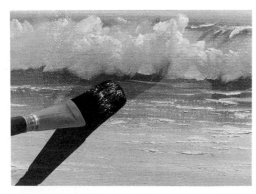

Here, the varnish is being applied with a brush. Notice the difference in color richness between the varnished and unvarnished portions.

When spraying varnish or any of these materials, it is wise to do it outside. This eliminates dust, mess, and fumes.

HAZARDS

It is impossible to predict how each person will react to some of the harsh chemicals and fumes that are present during oil painting. Each person has a different personal chemistry; therefore, each reacts differently. It must be pointed out that with the proper precautions and ventilation, the fumes and vapors are minimal. Food should never be present in the palette area and hands should be washed thoroughly prior to eating.

If one does not wish to allow the paint to come into contact with the skin, thin surgical-type rubber gloves are available from drug stores and are used successfully by persons with skin contact allergies. All of these paints, thinners and mediums should be kept out of the reach of children and pets, since smaller bodies have a harder time metabolizing any toxic material. It is always a good practice to keep any adult art materials away from children and pets.

The finest paint manufacturers participate in a product standard for risk evaluation that was established by the American Society for Testing and Materials (ASTM). This has resulted in product formulas being studied by toxicologists for potentially chronic adverse effects, with warnings to be included on the labels as necessary. This is monitored by the Arts and Craft Materials Institute; their appropiate labels are displayed on the products.

If the phrase "No Health Labeling Required" appears with the seal, this means that no specific warning information is required and that no special precautions are needed to use the product. Nevertheless, it is always wise to use a good common sense approach when working with any of these products.

All manufacturers are perfectly willing to supply you with information about a product and its use. If there is any question, do not hesitate to contact the maker of the product in question.

SURFACES AND SUPPORTS

Oil paints have been applied to nearly every type of surface imaginable — from fabric to glass, paper, wood, panels of wood particles, and metal. Some are successful and some give no longevity to the painting at all. These objects are known as the "support." In most instances, a sizing and then a primer must be applied to this support to act as a base for the oil paint to adhere to without peeling, cracking, wrinkling or shrinking. This priming is known as the painting "surface" or "ground."

Fabrics are usually available unprimed, single-primed, or double-primed. A sizing or sealant of glue is applied to the fabric and then a single or double coating of polymer Gesso or underpainting oil white is applied. Gesso is a polymer primer, while the oil primer can be of flake (lead) white or a specially-prepared oil underpaint. With today's polymer Gesso, the sizing step is unnecessary in many cases, and the surface is acceptable for either acrylic or oil paints. However, oil paints should never be applied directly to an unsized fabric because the oil will cause the fabric to deteriorate over time.

Only the most successful supports and surfaces are listed here. Always use proven materials.

Sizing and Priming

Sizing

A good sizing should not be intended as a complete sealant layer through which nothing will penetrate. It should, however, allow for slight penetration of the primer and paint for bonding and breathing. It is used as a bonding layer when a priming paint will not adhere to the support. Sizings are generally made from the hides of various animals and brushed onto the support. Rabbit skin glue, for instance, is widely used. A water-base wallpaper sizing is available at paint stores for those who do not wish to experience the preparation of hide glues by heating them on their stoves.

True Gesso/Polymer Gesso

The true Gesso is made by mixing whiting, chalk or plaster of Paris to a glue or gelatin water-soluble binder. When dry, it is absorbent and will draw the oil from the paint into the Gesso, making it weaker. It draws oil out so rapidly that it is difficult to obtain any color blends at all because the brush drags and feels as if it were being dragged into the surface. This true Gesso priming can be used with oils if it is sized with a coating of shellac thinned with alcohol. Damar retouch varnish thinned with turpentine or petroleum thinners will also work. This sizing is not intended to be a complete sealant, but is to stop the absorbency of the true Gesso. Once dried, the panel can be used for oil paint. True Gesso is available from your local art supplier. Polymer or acrylic Gesso is made of just that — acrylic. It can be applied with a brush or a commercial spray can. It is suitable for direct application of oil paints and may only need a slight sanding for tooth. Polymer Gesso is available from your local art supplier.

Underpainting (Oil Whites)

Specially-formulated whites (underpainting whites) for priming painting surfaces are available from a number of manufacturers. They make an excellent painting surface. These whites dry rapidly and are very thick in consistency. They may be thinned with turpentine or petroleum thinners. Care should be taken to avoid accidentally incorporating these in general mixing and painting because the consistency and drying times are not compatible.

Fabric Supports

Fabrics are available in rolls and ready-made forms. They are rectangular, square, oval and circular. There are two fabrics that have proven to be the most successful supports for oil paints: linen and cotton. Of these two, linen is considered the best and most durable because of the strength of the fibers, the ease of stretching the material onto wooden stretcher bars, and the evenness of temperament to climate and moisture.

Linen

Linen is available in a number of textures, from very smooth (used for portrait and detailed techniques) to very rough. These textures are known as the "tooth" of the material. Rough material has more of a "tooth" than smooth material. Linen is far more expensive than cotton and, in many instances, is primed by hand. It is well worth the extra cost as paintings seem to have an extra richness when painted on linen. Linen is available in rolls of different widths and lengths and is either unprimed or single- or double-primed with polymer Gesso or oil. It is also available in ready-made canvases.

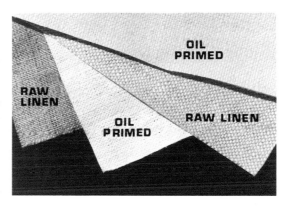

Cotton

Cotton is available in both rolls and ready-made canvases stretched onto wooden stretcher bars or glued onto a cardboard-type surface and folded over the back in the form of canvas boards. Cotton is available in a wide variety of textures and qualities. A good standard of quality is any good cotton duck from a known mill. Cotton is inexpensive and usually primed with polymer Gesso through an automatic process.

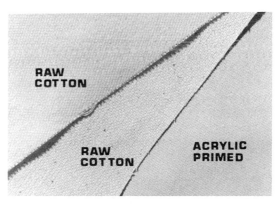

The painting above was done on the primed linen you see in the top photo. Notice the soft-textured tooth of the cloth.

This painting is on the primed smooth cotton canvas that is pictured in the middle photo. It is consistently smoother in weave than the linen.

Priming Fabrics

Fabrics are primed with the same methods as described under "Priming Pressed Wood Panels," but the fabric must be sized first (see page 50). Also, less sanding is needed as there is a natural tooth to fabrics. The maximum number of coats (especially on fabric) is three; any more and the movement of the fabric with atmospheric conditions can cause cracking. Follow the same steps described whether priming with oils or polymer Gesso.

Solid Wood Boards

The finest wooden panels for oil painting are ones of set cured solid hardwood such as oak, birch, poplar and walnut. These woods are expensive and are available through special order from lumber yards. They need to be sanded smooth. In many cases, the paint can be applied directly to the surface of the hardwood board without any sizing or priming. A glue sizing is sometimes required to stop oil penetration into the board. When a specific texture is desired, a priming of underpaint is necessary. There is a special feeling of control when painting oil directly onto a wood surface.

Plywood Panels

A smooth plywood with a veneer of good hardwood is more readily available and less expensive than the solid wooden boards. Care must be taken to purchase a plywood of high quality to insure the layers of glue and board are bonded properly. These panels of plywood are available from lumber yards in thicknesses from 3/16" and up. The most commonly used size is 1/4". A normal full sheet is 48" x 96" and, for a small fee, most yards will cut these to specified smaller sizes with fine precision. These boards may be used in the same manner as hardwood boards.

Pressed Wood Panels

There are a number of types of pressed wood panels available, but the best for oil painting are those containing no glue. They are manufactured by pressure and steam and are generally available with one very smooth side and an imprint of screening on the other side. A variety that is smooth on both sides is a little more expensive and can be specially ordered from your lumber yard. It is worth it as the lint factor is minimal.

These panels are available as "tempered" and "untempered." The tempered panels are impregnated with oil and should not be used for acrylic Gesso primings. They are, however, suitable for oil. The best for general use is the untempered because Gesso will adhere to this non-oily surface better. Either of these panels, when correctly primed, is an excellent support for oil painting.

Priming Pressed Wood Panels

Pressed wood panels must have a primed surface in order to accept oil paint properly. These primings may be applied with a brush or a spray gun for a smooth finish. A light sanding is done first with a wet-or-dry sandpaper (used dry) of 600-800 grit. Then a coat of polymer Gesso or oil primer is applied, brushing in a horizontal direction. When dry, another light sanding is done and another coat of primer is applied, brushing vertically across the first coat (this will give a slight canvas-grain appearance to the surface). A final, very light sanding is done to establish a tooth, and the panel is ready to paint. (If a third coat is desired, it should be brushed on in the same direction as the first coat). Some artists apply a thin layer of glue sizing before priming.

Pressed Wood Panels (Ready-To-Use)

There are ready-to-use, commercially prepared pressed wood panels primed with Gesso available in a variety of sizes from art supply stores. The surface is extremely smooth for detail work since it has been applied by spray or roller. These panels are priced about the same as a mid-quality, ready-to-use cotton canvas and are handy for student work and for those without the facilities to spray their own. Caution: Determine whether these panels are primed with true Gesso or polymer Gesso. If true Gesso, the panel will need to be sized before applying oil paint (but not acrylic).

Academy Board/Illustration Board

Both of these are basically good quality cardboard. Most academy boards have a simulated canvas surface and come primed for oil paint. Illustration board must be primed with polymer Gesso. Either of these is a good surface to practice on if properly treated. A good cold-pressed 100 lb. illustration board has an excellent surface with a tooth that produces a slight grain to the finished painting, different than canvas. This surface is a good one for detail work and sketches. The light weight of these boards makes them handy for field trips.

Canvas Pads

These pads are textured to resemble canvas and made with paper treated to accept oil paint. Some are cotton-backed. They are good for practice exercises and field sketches; pages may be torn out of the pad and inserted into a notebook when the paint is dry. They are available in an assortment of sizes from 9"x12" to 18"x24".

Standard Sizes

The following is a listing of standard sizes available for ready-made canvases and frames:

8x10	16x20	24x36
9x12	18x24	30x40
11x14	20x24	12x24
12x16	22x28	15x30
14x10	24x30	24x48

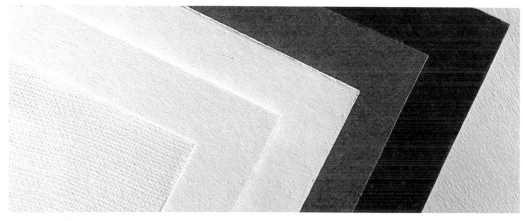

The supports shown above are (from left to right): canvas pad paper, primed illustration board, primed pressed wood board, unprimed and untempered pressed wood board, unprimed and tempered pressed wood board.

Stretcher Bars/Wedge Keys

Stretcher bars are wooden strips that are tongued and grooved on the ends for interlocking with one another. They are also machined with a slight lip for the canvas to ride over. They are available in standard and mini sizes. A wooden key is used for the control of tautness. They are made in varying lengths of standard sizes, but special sizes can be ordered from some suppliers. If they are not available, a good cabinet or carpentry shop will be able to make them. Many artists make their own, but the perfection of the tongue and groove and the ability to key them is lost.

Stretching Canvas Onto Bars

Canvas stretching pliers are needed. These are specially made with a wide mouth to grip the fabric with a uniform pull (as shown in the following photos). Canvases can be secured to the bars with either copper-plated steel tacks, regular steel carpet tacks, or a staple gun.

1. Select the size bars desired and join them at the corners.

2. Square the corners of the joined bars on the edge of a table or desk, as shown, or use a square.

3. Cut a piece of canvas three inches wider and longer than the area covered by the outside edge of the bars.

4. Place the canvas onto a flat surface with the primed side down and set the stretcher bars onto the back of the canvas. You should have a minimum of 1-1/2 inches around each side.

5. Fold the center of one end of the canvas over the bar and staple it.

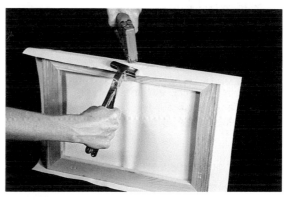

6. Using the stretcher pliers, grip the opposite end in the center and gently stretch until canvas is taut and a slight depression is visible. Place a staple in the center.

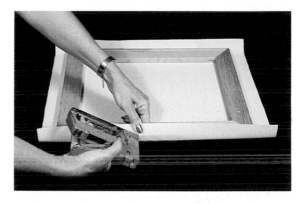

7. Find the center of one side and stretch the canvas until slight wrinkles appear from the first two stapled areas to this pull. Staple there.

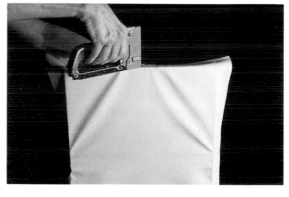

8. Repeat this procedure on the other side.

9. Move the pliers about an inch to the right and pull until the wrinkle moves to the right. Staple again. Repeat in this direction until about three inches from the end or until the wrinkle will not move. If wrinkles stop moving with pliers, do not pull harder but go to the center of the companion side and start the procedure by moving from the center to the left. It is sometimes necessary to work to a corner by working both sides alternately.

10. When the corner is reached with the back facing you, place a staple in the corner of the right side. Fold the canvas under on the left side and pull with the pliers until the same tautness is reached and all wrinkles are gone. Place one or two staples there on the fold.

 Repeat this procedure all around the canvas until it is fully stretched.

11. Trim off all excess canvas using a knife or a razor blade. The practice of folding excess canvas over the back and stapling down is not a good one if the paintings are to be stacked. Any movement between them causes the excess canvas to act as sandpaper, marring any painted surface it comes into contact with. It is best if it is trimmed away.

PALETTES

A palette is the surface on which the colors are placed, mixed, thinned and then removed with the painting tool. They come in various shapes and sizes and some fit into wooden paint boxes as part of a kit. The traditional large wooden arm palette is used less and less today because of its dark color and the desire to keep both hands free to work. White and light values of grey are the most desired colors for palettes today. Palettes may be made of any nonabsorbent surface, from glass to metal, plastic and wood. Old china plates work well, but are limited in size. In the studio, a glass palette is most useful. A glass palette should be made of

a good quality plate glass and not of thin window glass for safety purposes. The sides should be ground smooth and free of sharp, raw edges. Your local glass supplier can do this. It can be placed on a table or stand next to the easel in the studio. Glass has several advantages: different colored backgrounds can be placed under them when mixing colors for different painting schemes, and they clean up by scraping with a razor and a little thinner. A clean palette and good palette discipline will carry through into the painting.

Palettes: Disposable

Good palettes for travel and class work are the ones made from treated papers. They are made in several sizes, the most popular being 12"x16", and are available in pads from which individual sheets may be torn off and discarded (this saves clean-up). Care must be taken not to mix and scrape the colors too hard when using these paper palettes. Wax or part of the paper will roll up in little specks, embedding themselves into the paint and leaving a furry look to the palette (see photo). Never over-mix colors (see *Color and How to Use It* in the Artist's Library Series).

DRAWING MATERIALS FOR OILS

Though preliminary marks and lines may be made on the primed, ready-to-paint surface by any number of items, care should be taken to use only those that will insure permanence in the work. Nothing should be used that will cause weakening of the painting with age. For this reason, only the simple, proven materials are listed here. There is no reason for a long procedure of placing the subject onto the canvas, or any painting surface for that matter. Precise drawing and guidelines are fine. However, a labored drawing with a buildup of drawing material will tend to shield the paint from the primed surface.

Many artists sketch with oil paint and thinner. This makes a light wash that is certainly compatible with the overpainting since it is of the same material.

Charcoal

Charcoal is one of the oldest drawing tools. It is considered better than graphite because it is not as greasy and will not erode oils. It is made by charring vines and twigs of selected woods. It comes in various grades of softness. The harder the charcoal, the less it has been charred. The hardness is rated on the sticks —soft, medium and hard. Charcoal is also ground and combined with a binder and manufactured in pencil form. The hardness is then rated with an "H" or a "B." The H series is harder and the B series softer. A number usually accompanies these rating letters, for example: 2H and 4H, 2B and 4B. The higher the number in the H series, the harder the charcoal. The higher the number in the B series, the softer the charcoal. These pencils are sometimes labeled carbon pencils. All of these forms are inert and are most desirable for preliminary drawing when painting in oil.

The drawing should be done lightly. Then a wash of oil color well-thinned with turpentine or petroleum thinners is drawn over the charcoal lines. This makes a permanent image on the canvas and all the excess charcoal dust can be brushed or blown lightly away. Any charcoal residue left can alter the colors. A light spraying of charcoal fixative or very light Damar retouch varnish will insure that no smudging takes place. Be cautious — do not spray so much that you seal the canvas!

Drawing Paper and Pads

These papers come in both single sheet and pad form in a variety of qualities, from newsprint to good-quality rag paper. They also come in a variety of surface textures. The one selected for preliminary sketching and drawing is a personal choice, but the high-quality papers are usually reserved for final drawings. Drawing pads and layout pads are available in various sizes — 18"x24" is a good size. You can cut the paper down to the size needed, but if the larger size is called for, you have it. Paintings should be sketched and compositionally laid out on paper, then after all the problems have been corrected in this form, the drawing can be transferred to the canvas. Planning and erasing on a ready-to-paint canvas can be disastrous. Not only does it destroy the painting surface, but we never have a completely thought-out work of art. Using these sketch pads, we sketch until it is right, then transfer it and paint it.

Tracing Paper and Pads

These papers also come in individual sheets and pads in a variety of qualities. A good-quality tracing paper is important so that it will not tear half-way through the tracing. Again, a number of sizes are available and 18"x24" is a good size. This paper is laid on top of the drawing and secured against slipping. Then, using a finely-sharpened pencil, go over the outlines of the drawing. To protect a finished-quality drawing from indentation of tracing, place a sheet of clear plastic over the drawing and place the tracing paper onto the plastic. Upon completion, the outlines of the original drawing can be transferred onto the painting surface.

Transfer Paper

Transfer paper is available in dark colors and white. It is known as "graphite paper" and is used to transfer a final drawing to the painting surface. By placing this paper on the painting surface, with the graphite side down and the tracing paper on top, the tracing can be transferred by simply going over the lines with a sharp pencil. The drawing is clean, light and well-defined. Do **not** use typewriter carbon as it will eventually erode the paint. Very little fixative is needed, if any.

Fixatives

Fixatives are thinned resins and shellacs that are sprayed onto a drawing surface to prevent smudging or smearing. In the case of a charcoal drawing on canvas, it is intended to protect the ensuing layers of paint from being changed by the charcoal. If little charcoal exists after going over the drawing with a wash of paint, little or no fixative should be used. In any event, it should never be used thickly as a sealer. It is available in spray cans and in liquid form. The liquid form is sprayed on with an atomizer.

Workable fixative is one that is meant to be used during the construction of a drawing without completely sealing it. It, too, is available in spray cans.

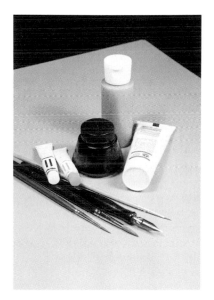

Inks, Watercolors and Acrylics

Permanent drawing inks, such as waterproof india ink, watercolors and thin washes of acrylics, may be used for drawing and sketching on a painting surface. These materials do not require a fixative and they make a good under-drawing that will not harm the oils. Inks should be applied very lightly as they can be difficult to hide unless painted over very thickly. Ball point pens are not a good tool as the ink in some of them will undermine the paint and eventually erode to the surface.

Acrylics can also be used for underpainting and sketching. Always remember that you can paint oils over acrylics, but never paint acrylics over oils. They will not bond and the painting will deteriorate.

A preliminary sketch with charcoal on grey primed canvas has been painted-over with a wash of thinner and ultramarine blue.

In this photo, the basic drawing was done with pure acrylic paint thinned with water. It is painted onto a canvas primed with very light grey.

EASELS

An easel is an upright frame designed to hold a painting support in a certain position. In oil painting, the most common position for the canvas is vertical. It can be at whatever angle is comfortable for the painter. However, by holding the painting plane vertically, it can be viewed from a number of angles and distances. This is important and helpful in observing composition, and perspective (see *Perspective* in the Artist's Library Series) and viewing the overall painting while working.

Easels come in numerous styles and sizes. There are large and small studio easels, lighter weight ones, table models and portable easels.

Studio Easels

The large, heavy studio easel is intended to hold works of all sizes. They are usually constructed of good hardwood and are designed in several styles. One type can be mounted to the wall for extra-large or heavy canvas. In some studios, a permanent easel has been attached directly to the wall because the artist works mostly on grand sizes and the floor easel will not hold the massive pieces. The studio easel can be adjusted for the artist to sit or stand while working.

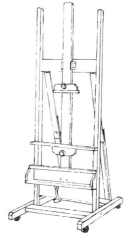

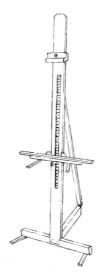

Lighter Weight Floor Easels

These are lighter versions of the studio easel, made of either wood or metal, with less framework and stability. They are surprisingly capable of supporting work in a satisfactory manner, but not as well as one of the strong studio design. These easels are also fully adjustable for either sitting or standing while working.

Portable Easels

Portable easels are made from wood, plastic or metal. Of these, the metal are the most durable and collapse easily for storage and transport. They are able to hold very small to quite large pieces (around 20″ x 24″ and slightly larger). Some metal easels have prongs that can be adjusted to "bite" into the ground for stability while painting outdoors. A heavy weight tied to a rope and suspended from the middle of these lightweight easels helps them stay in place during a windy day or a rough painting spree.

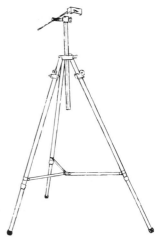

Table Easels

There are many styles of table easels available. They are made of wood, plastic or metal. The adjustable metal kind are sturdy and capable of holding fairly large works. These easels allow the artist to work while sitting at a table. They are especially handy for classroom work. Some beginners make a temporary portable easel/paint box combination by cutting a cardboard box as shown in the photo below. Paints and tools can be carried to class inside the box.

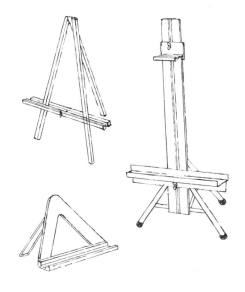

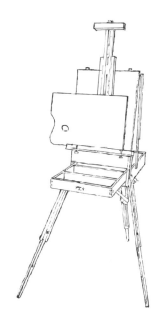

The French Easel

The French easel is a design that combines an easel, paint box, and canvas carrier in one unit. The best ones are made of hardwood and are finely crafted. French easels allow the artist to carry a couple of small canvases, paints, palette, brushes, mediums and thinners into the field in one compact unit. Once there, it is unfolded and used as a work table and easel. The finest ones are expensive, but a well-made French easel can last an artist a lifetime.

Here, a homemade, temporary easel was made from a book shipping box. The size of the box determines how large the canvas can be.

This homemade easel is one I made from 1" x 2" scrap pine boards. Any scrap wood can be used to make one like it.

MISCELLANEOUS EQUIPMENT

Palette Cups

In the studio, most artists use jars or other containers to hold their painting mediums and thinners. In the field or on a palette held by hand, palette cups are handy tools. They are available in metal or plastic, single or double, and attach to the edge of a palette. They hold small usable amounts of mediums and thinners. They are very inexpensive. Some have screw-on lids for storage.

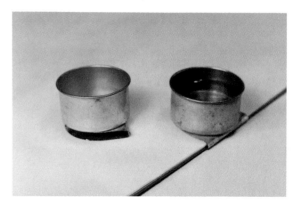

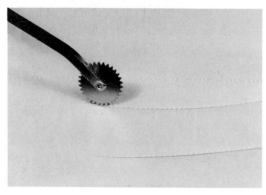

Maulsticks

Maulsticks are long, lightweight sticks that are used to steady the painter's hand. The one shown here was homemade with a wooden yardstick with paper towels wrapped on the end to protect the painting. While holding one end, the other end is placed on the edge of the canvas. It then can be used to steady the painting hand. They are available commercially in metal telescope-type tubes or solid wood. A wooden dowel also works well.

Empty Paint Tubes

Empty paint tubes can be used to store colors an artist has mixed in quantity. Mixtures that are used frequently can be made in advance and then squeezed from the tube like commercially prepared paints. The tubes are loaded from the bottom, then folded and crimped for storage. A stick-on label or permanent marker can be used to mark the color. It is a good idea to include the date and the basic recipe.

Pounce Wheel

This is a wheel with a serrated edge for penetrating an outline or drawing. The teeth punch holes in the paper. The perforated drawing is then positioned firmly to the painting surface. Light chalk or powder on a dark surface, or dark on a light surface, are pounced through the perforations leaving a general outline of the drawing that can then be refined. This technique is used mostly in very large works such as murals.

Pounce Powder

Pure charcoal and chalks in powder form are available. These powders are placed into a cloth bag (an old t-shirt works well), tied with string or rubber bands, and then pounced onto the perforated drawing pattern. There are pounce pads available for those who do not wish to make their own.

Atomizer

There are a number of devices called atomizers. They are designed to break a solid liquid into minute droplets, as in a spray mist. The mist must be very fine. A number of hand-operated spray atomizers are available. A device made of two small metal or plastic tubes is popular. It is powered by the artist by placing one end of the angled tube in his or her mouth and the other in the jar of liquid to be sprayed — fixative, varnish, etc. By blowing into the tube, the liquid is drawn from the bottle and converted into a spray mist. The more forceful the breath, the more spray produced.

Canvas Pins and Clips

These are items that allow you to stack paintings while they are wet. They hold the canvases apart while drying. The problem with these is that they leave an impression in the wet paint and the pins sometimes make a permanent hole in the canvases. It is better to be patient and allow nothing to touch the face of a painting while it is drying.

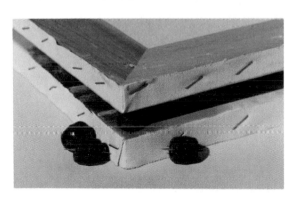

Paint, Sketch, and Brush Boxes and Caddies

There are so many varieties of paint and brush boxes and caddies on the market that it is impossible to show them all and describe them except generally. The selection is a matter of personal choice and need. Simply put, they are boxes made of wood, plastic or metal that are designed to carry paints, painting supplies and brushes in one convenient container. There are also boxes especially designed for brushes only.

PICTURE CLEANING AND CLEANERS

Oil paintings should be protected from any harsh environment that will prove harmful to the paint. In most homes, however, no matter how hard we try, the cooking oils and residues of sprays settle on the surface of the painting. If the painting has been exposed to any tobacco smoke, there will be a film deposited on the painting. Paintings appear to become duller or darker with age. Two factors contribute to this: the darkening tone of linseed oil from being enclosed in a dark room, and the films just discussed. Both can be corrected.

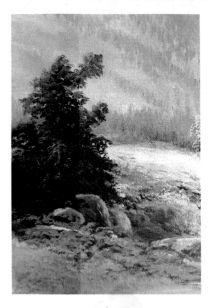

The cleaning or clearing of these films is not always a simple matter, however. Tests should be run along an edge of the painting and, if no painting color is being lifted by the chemical chosen for the cleaning job, then it is safe to proceed. Several manufacturers make products for cleaning oil painting surfaces. These are fine products and each is labeled as to what it will do, and instructions for using. Care must be taken to read the information about each one and select the right one for the job.

Some cleaners will remove the outer layer of varnish, so care must be taken to constantly watch for any painting color as the artist may have used a weak varnish for an isolating varnish which may be removed easily. After the cleaning process is completed, the painting is then revarnished with Damar Final Varnish. The darkening of the linseed oil can be corrected by exposing the painting to north daylight. Do not place the painting at a direct angle to the sun so it becomes hot, but do allow rays of daylight to strike it. If the work is delicate or fragile at all, indoor exposure from a closed window will work. Within a few hours or days, the oil will usually clear and the painting will lighten and appear as fresh as new.

This information is intended as a guide for paintings that have been accomplished within the standard realms of the practice of oil painting. Always proceed cautiously when attempting to clean any painting. By following the proper instructions, it becomes a simple task.

The painting in the photo has been cleaned and revarnished on the left. Notice how much richer the color and detail are than on the uncleaned portion.

CLOSING THOUGHTS

It is imperative for oil painters to have an understanding of the materials used and to use only products that have been properly prepared for the art of oil painting. Finely prepared products are more expensive than the bulk forms, but there are no cheap substitutes. For example, to use an impure, cheap grade of linseed oil to thin expensive oil paints would be disastrous because over time the acid and impurities would destroy the work.

Also, try to avoid so-called time- and money-saving gimmicks that are commonly passed around in today's "hurry-up" world as they can ruin a work. One example would be to use oven cleaner to remove paint from a canvas in order to reuse it. This is a terrible practice and will ruin any work painted over it. It is best to start with a fresh canvas. When these types of questions or suggestions come up in my classes, I tell the students, "If it is not inert or prepared for art, DON'T USE IT FOR ART!"

I would like to say in closing that I hope the information presented here is helpful and that this book will become a handy reference guide to assist you in the art of oil painting.